IMAGES
of America

BREAUX BRIDGE

ON THE COVER. The people of Breaux Bridge gathered on April 10, 11, and 12, 1959, to celebrate the centennial of the city. Most of the city's population of 5,000 participated in the celebration. Crowds of over 75,000 were estimated to have attended the three days of festivities. Former residents and descendants of the original settlers came from various parts of Louisiana and Texas. The celebration began with a Pontifical High Mass by Bishop Maurice Schexnayder of St. Bernard Catholic Church on the morning of April 10. This was followed by a parade down Main Street, led by Fr. Paul Patin. (Courtesy St. Martin Library.)

IMAGES
of America

BREAUX BRIDGE

Renae Friedley

ARCADIA
PUBLISHING

Published by Arcadia Publishing
Charleston, South Carolina

Printed in the United States of America

Library of Congress Control Number: 2013942514

For all general information, please contact Arcadia Publishing:
Telephone 843-853-2070
Fax 843-853-0044
E-mail sales@arcadiapublishing.com
For customer service and orders:
Toll-Free 1-888-313-2665

Visit us on the Internet at www.arcadiapublishing.com

*This book is dedicated to the Acadians who settled in South Louisiana
and established the many wonderful traditions, and cuisine, that
the people of Louisiana enjoy. Laissez les bon temps rouler!*

CONTENTS

FOREWORD

Breaux Bridge was the best small town a kid could grow up in. It was flat, perfect bike-riding territory, something I was grateful for because my main mode of transportation was a Schwinn Sting-Ray bicycle. I traveled far and wide on my Sting-Ray, discovering the people and places that make Pont Breaux so special.

There was the Bayou Teche, an ideal place for endless contemplation and adventure. It was where kids could fish, teenagers could water-ski, and adults could find romance. The bayou was our backyard, and it was beautiful to behold. The Teche was even a source of music, if you consider the hum that emanated from the iconic bridge when cars drove over the dark water.

Things weren't always perfect. When long-overdue school integration finally came, the town was uneasy. But for the most part, the process was not traumatic. We grew and became a better community because of it.

There were movie theaters (the Jeff and the Laine), department stores (Fontenot & Guidry's, Western Auto), and the public swimming pool. Downtown was bustling, the buildings still bursting with a 19th-century "can-do" attitude. Almost all of these businesses are gone, and today, Interstate 10 is our concrete river. It's a lot less noisy downtown. But that means that the quiet call of what is most important—heart, home, and heritage—is easier to hear for those who want to listen.

My childhood is gone, but images of my hometown remain with me, and those memories are etched upon my heart.

—Sam Irwin
July 2013

ACKNOWLEDGMENTS

I wish to thank the City of Breaux Bridge for its contributions and assistance in compiling this book. In particular, I want to thank the Breaux Bridge Department of Tourism, especially Lynn Roy, the Crawfish Festival Association, and the St. Martin Parish Library. I especially wish to thank Gale (Gravouilla) Smith for her support and assistance, and for introducing me to Breaux Bridge and its many wonderful residents. I thank her friends and family who shared their stories and photographs, especially Emmaline (Hebert) Thibodeaux, Shirley Landry Robert, Janet Boudreau Landry, and Gerald Champagne. Thanks also go to Kenneth P. Delcambre, Sam Irwin, Johnny Raymond, and Kim Dever Thibodeaux, who provided photographs and historical information about Breaux Bridge. This was a wonderful, fun, and enlightening experience that I will always cherish.

Unless otherwise noted, all images are from the St. Martin Library.

INTRODUCTION

In 1755, thousands of French inhabitants of Nova Scotia were deported and dispersed among the British colonies in America. Documents reflect that this was done for two reasons: the British wanted their rich farmland, and they wanted to dispel the rebellious French Acadians from Canada, which was now a part of the British Empire. They were exiled with the clothes they wore and what few possessions they could carry. The Acadians of Chignecto were dispersed to the southern colonies of South Carolina and Georgia. Those from Annapolis Royal and Minas were sent to Virginia, Maryland, Pennsylvania, New York, Massachusetts, and Connecticut, in groups not to exceed "one thousand persons in order to discourage them from organizing as a group."

Historians disagree on how *les Acadiens* arrived in Louisiana. Some argue that they arrived overland, coming across the Appalachian frontier, to Louisiana. Others believe that they arrived here by schooner from Saint-Domingue (Haiti). Among the Halifax Acadians who sailed to Saint-Domingue by schooner were Joseph Broussard and Alexandre Broussard, including every living relative, as well as the family of many of their associates. The Broussards did not remain in Saint-Domingue but soon hired another vessel and, with 193 other Acadians, continued on to the French colony of New Orleans, where they arrived in February 1765.

From New Orleans, they traveled to the Bayou Teche country. Charles Philippe Aubry, the acting governor of Louisiana, welcomed the exiles. However, soon after their arrival, many succumbed to an unknown epidemic, presumed to be yellow fever. The arrival of the Broussard group to La Pointe (Breaux Bridge) and Parks, Louisiana, marks the first Acadian settlements in the United States. They were joined a few weeks later by another large group. By the end of 1765, documents show that nearly 500 Acadians were living in settlements in the Attakapas District. The Spanish census of April 25, 1766, reflects that some of these Acadians were found living at La Pointe (Breaux Bridge). By the end of the decade, the area was home to a growing population of Acadians, three quarters of whom had originated at Chignecto or Chipoudy Bay.

What evolved from these first settlements was a culture known as Cajun. While there are several different cultures throughout Southwest Louisiana—Spanish, Creole, African American, Native American, etc.—I believe that the Cajuns have exerted the greatest influence on the music, cuisine, religion, and traditions of Louisiana. This culture is reflected in the following images of Breaux Bridge.

One

BAYOU TECHE
AND THE ACADIANS

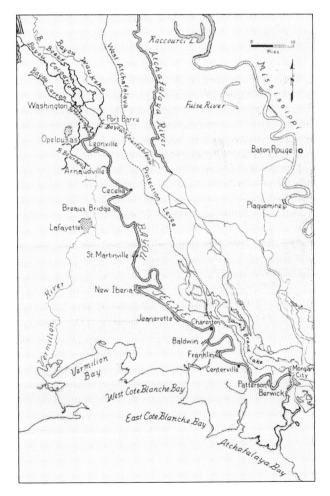

La Pointe de Repos was established
along a bend, or point, on the
Bayou Teche, a Chitimacha word
meaning "snake." It is a 125-mile-
long waterway that meanders
through Cajun country. Beginning
in Port Barré, it wanders south
through the towns that were
established along its banks until it
finally flows into the Atchafalaya
River. Bayou Teche was the
Mississippi River's main course
when it developed a delta through
a natural process known as deltaic
switching, sometime between
2,800 and 4,500 years ago.

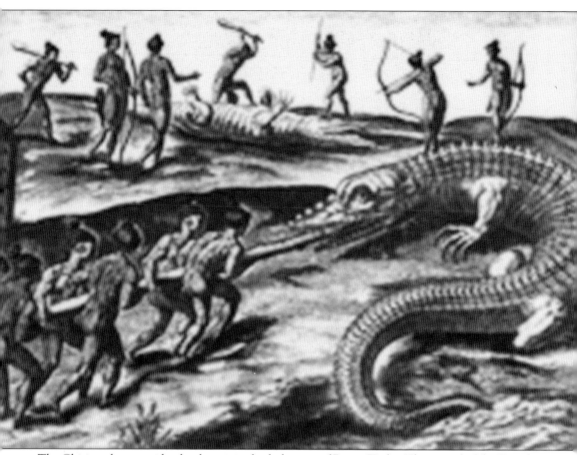

The Chitimacha are said to be the original inhabitants of Bayou Teche. The arrival of the French and Spanish colonists in the 18th century resulted in a drastic decline of their population due to wars with the colonists and exposure to infectious diseases. The arrival of the Acadians brought a further decline in the Chitimacha population. The tribal leadership sold what was left of the Chitmacha land to the US government in 1917. By 1930, the Chitimacha population had dropped to just 51 people; however, since then, the population has grown. The 2000 census reported a resident population of 409 persons living on the Chitimacha Indian Reservation in Charenton, near Baldwin, Louisiana. Of these, 285 were of solely Native American ancestry. They listed their languages as English, Chitimacha, French, and Cajun. The legend of Bayou Teche comes from the Chitimacha: "Many years ago . . . there was a huge and venomous snake. This snake was so large, and so long, that its size was not measured in feet, but in miles. This enormous snake had been an enemy of the Chitimacha for many years, because of its destruction to many of their ways of life. One day, the Chitimacha chief called together his warriors, and had them prepare themselves for a battle with their enemy. In those days, there were no guns that could be used to kill this snake. All they had were clubs and bows and arrows, with arrowheads made of large bones from the garfish. . . . The warriors fought courageously to kill the enemy, but the snake fought just as hard to survive. As the beast turned and twisted in the last few days of a slow death, it broadened, curved and deepened the place wherein his huge body lay. The Bayou Teche is proof of the exact position into which this enemy placed himself when overcome by the Chitimacha warriors."

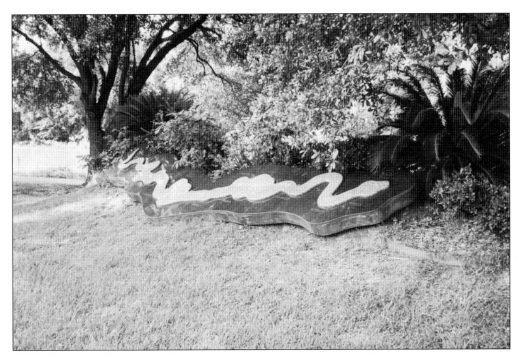

In celebration of the Chitimacha legend, Breaux Bridge commissioned a 20-foot-long snake sculpture (above), which shows all of the towns along Bayou Teche, and a commemorative marker (right) to remind visitors of the legend. The snake sculpture, located in Parc des Ponts de Pont Breaux, highlights the significance of the bayou to the Acadians, as the bayou once served as the primary highway for the region. The snake is constructed from a solid piece of violetta granite from Saudi Arabia, which was cut into five pieces and re-jointed. The snake is mounted onto a 25-foot piece of absolute black granite from Zimbabwe. Carved into a kiosk-shaped piece of granite located near the sculpture is the legend of Bayou Teche. (Courtesy City of Breaux Bridge.)

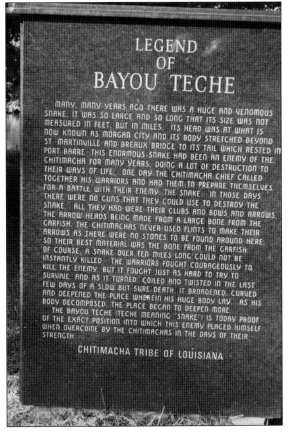

LEGEND
OF
BAYOU TECHE

MANY, MANY YEARS AGO THERE WAS A HUGE AND VENOMOUS SNAKE. IT WAS SO LARGE AND SO LONG THAT ITS SIZE WAS NOT MEASURED IN FEET, BUT IN MILES. ITS HEAD WAS AT WHAT IS NOW KNOWN AS MORGAN CITY AND ITS BODY STRETCHED BEYOND ST. MARTINVILLE AND BREAUX BRIDGE TO ITS TAIL WHICH RESTED IN PORT BARRE. THIS ENORMOUS SNAKE HAD BEEN AN ENEMY OF THE CHITIMACHA FOR MANY YEARS, DOING A LOT OF DESTRUCTION TO THEIR WAYS OF LIFE. ONE DAY THE CHITIMACHA CHIEF CALLED TOGETHER HIS WARRIORS AND HAD THEM TO PREPARE THEMSELVES FOR A BATTLE WITH THEIR ENEMY, THE SNAKE. IN THOSE DAYS THERE WERE NO GUNS THAT THEY COULD USE TO DESTROY THE SNAKE. ALL THEY HAD WERE THEIR CLUBS AND BOWS AND ARROWS, THE ARROW HEADS BEING MADE FROM A LARGE BONE FROM THE GARFISH. THE CHITIMACHAS NEVER USED FLINTS TO MAKE THEIR ARROWS AS THERE WERE NO STONES TO BE FOUND AROUND HERE, SO THEIR BEST MATERIAL WAS THE BONE FROM THE GARFISH. OF COURSE, A SNAKE OVER TEN MILES LONG COULD NOT BE INSTANTLY KILLED. THE WARRIORS FOUGHT COURAGEOUSLY TO KILL THE ENEMY, BUT IT FOUGHT JUST AS HARD TO TRY TO SURVIVE, AND AS IT TURNED, COILED AND TWISTED IN THE LAST FEW DAYS OF A SLOW BUT SURE DEATH, IT BROADENED, CURVED AND DEEPENED THE PLACE WHEREIN HIS HUGE BODY LAY. AS HIS BODY DECOMPOSED, THE PLACE BEGAN TO DEEPEN MORE.
THE BAYOU TECHE (TECHE MEANING "SNAKE") IS TODAY PROOF OF THE EXACT POSITION INTO WHICH THIS ENEMY PLACED HIMSELF WHEN OVERCOME BY THE CHITIMACHAS IN THE DAYS OF THEIR STRENGTH.

CHITIMACHA TRIBE OF LOUISIANA

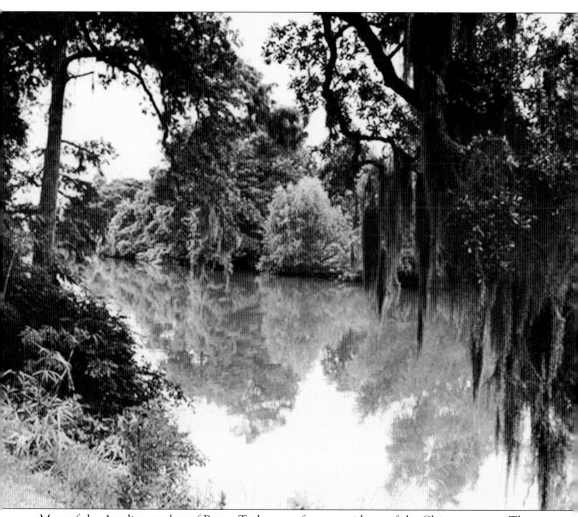

Most of the Acadian settlers of Bayou Teche were former residents of the Chignecto area. They had been cattle ranchers, and husbandry had been the foundation of their economy. Therefore, the lush prairie land along Bayou Teche in Southwest Louisiana seemed an ideal area to settle. They quickly adapted to the region's mild climate. The census of 1766 reflects that the district had five cattle ranches, 20 leagues of land claimed to have been granted to five individuals, 15,000 head of cattle, 100 pigs or sheep, and 50 muskets. Firmin Breaux was one of the Acadian exiles shipped to Boston, Massachusetts, with his family. However, when the family left Boston, the 17-year-old Firmin followed Joseph Broussard to Louisiana. In 1766, Firmin Breaux was listed as a resident at Bayou Tortue. From there, he traveled to St. Jacques de Cabannocé (present-day St. James Parish), where documents show that he married Marguerite Braud. He is listed in the 1769 census of the area. However, records reflect that Breaux began purchasing land from the estate of Jean-Francois Ledee, who had received land from a grant from the Spanish government. Breaux began to purchase Ledee's land from his agent, Solomon Malines, in October 1771. By 1774, Breaux's branding iron was registered, and by 1786, he was one of the largest property owners in Teche country. (Courtesy Kenneth Delcambre.)

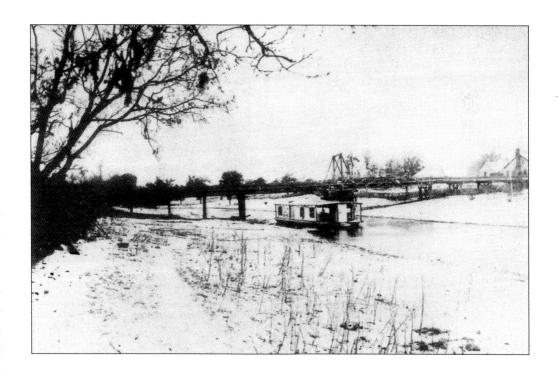

According to historian Kenneth P. Delcambre, the camera was not introduced to Breaux Bridge until 1879. The first images of Breaux Bridge were taken by J.S. Savoy, who had a floating studio that periodically came up the Bayou Teche to take photographs of the citizens and the town. These photographs, the first taken in the area, depict a snowfall in 1879. (Courtesy Kenneth Delcambre.)

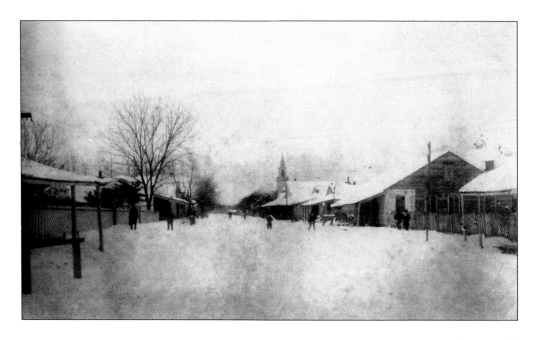

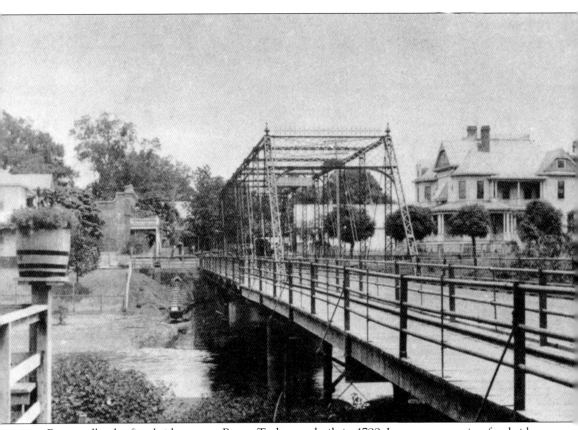

Reportedly, the first bridge across Bayou Teche was built in 1799. It was a suspension footbridge, likely made of rope and small planks and stabilized by being tied to pilings located at each end of the bridge, as well as to a pair of huge live oak trees on both sides of the bayou. It was the first bridge that connected the east bank of Bayou Teche to the west bank and was built by Firmin Breaux to connect his land on the west bank to that of his sons, Joseph and Agricole, on the east bank. It also facilitated access to Firmin's cotton gin on the west bank for the farmers in the area. It is recorded that when Firmin Breaux died on October 1, 1808, he was living at the west end of the bridge, where there was a cotton gin and ferry. Agricole Breaux built the first vehicular bridge in 1817. A toll bridge that allowed for the passage of wagons, it increased commerce in the area. This bridge appears on the legal documents for the Plan de la Ville du Pont des Breaux that were submitted by Scholastique Breaux in 1829. The steel bridge shown here was built in 1899.

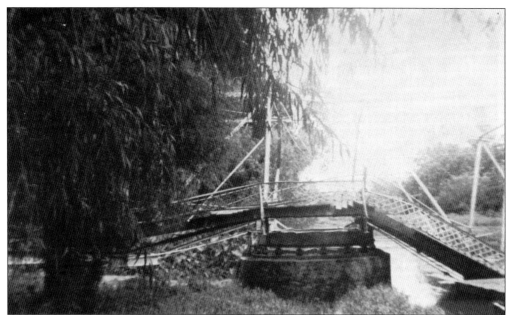

To allow for the lifting of the bridge so that boats could pass through, the 1817 span was modified around 1845. This bridge was in service until 1891, when Harville Hollier was given $3,600 to construct a new bridge. In 1899, a steel bridge was erected by the King Bridge Company of Cleveland for $6,950. The photograph above shows the steel bridge, which collapsed on July 12, 1949, while attempting to allow a boat through. A temporary pontoon bridge was built to facilitate pedestrian traffic while the railroad bridge was utilized by vehicles. (Courtesy Kenneth P. Delcambre.)

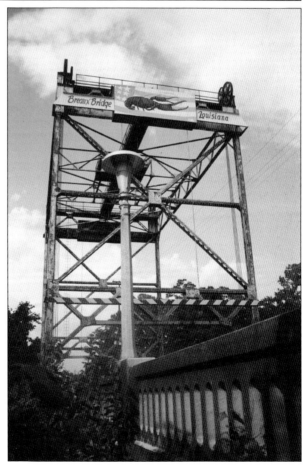

At a cost of $233,728, the current bridge (shown here) was built in 1950 by J.P. Ewin, Inc., of Mobile, Alabama. The steel bridge has a vertical lift span and concrete approaches. The first person to drive over the bridge was Ana Belle Dupuis Hoffman Krewitz in her Model A Ford.

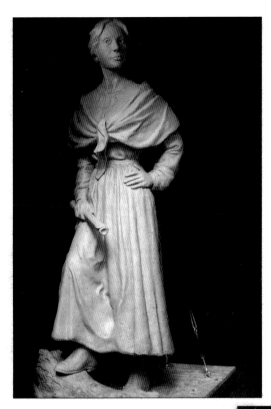

Scholastique Picou Breaux, the wife of Agricole Breaux (son of Firmin), is credited with the founding of Breaux Bridge in 1829. Finding herself in financial difficulties after the death of her husband on May 2, 1828, and with five children, the 33-year-old widow was motivated to draw up the Plan de la Ville Du Pont des Breaux, the plan for the Village of Breaux Bridge. The plan included a school, church, a diagram of streets, and a detailed map of the area—including her late husband's bridge. She then proceeded to sell lots, resulting in Breaux Bridge's founding date of August 5, 1829. Scholastique remarried and became the mother of two more children. She has many descendants, some of who were responsible for the commission of her statue, shown here. (Courtesy Celia Guilbeau Soper.)

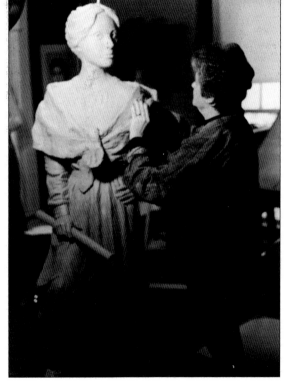

Sculptor Celia Guilbeau Soper (great-great-granddaughter of Scholastique) was commissioned to create a life-sized statue of Scholastique by the Women of Breaux Bridge, a group whose sole purpose was to honor Scholastique as the founder of the city. Over 300 women donated $100 each toward the creation of the statue. (Courtesy Celia Guilbeau Soper.)

Since there are no known photographs of Scholastique Breaux, Celia Soper enlisted her 35-year-old daughter, Rebecca "Becky" Lowe, to model for the statue. Lowe was around the same age and said to be about the same size as Scholastique at the time that she founded the city. (Courtesy Celia Guilbeau Soper.)

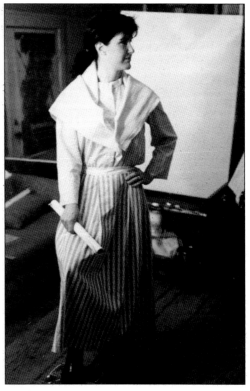

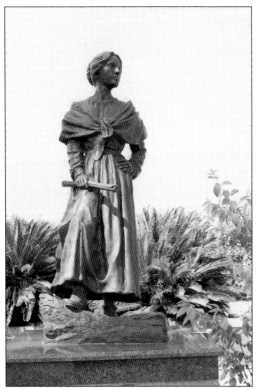

Scholastique and Agricole's children included the following: Emile, Arthemise, Caliste (wife of Alexandre Hebert, then of Charles Rees), Elmire (wife of Jean-Baptiste David), Erasie (wife of Alexis C. Guidry), and Azelia (wife of Alexandre C. Guidry). After Agricole's death, Scholastique married Jean-Francois Domengeaux and had two children with him, Linvale and Teresite Domengeaux. Many of her descendants are residents of Breaux Bridge and Lafayette. She died on September 21, 1848. The bronze statue honoring Scholastique Picou Breaux was unveiled on August 12, 1998.

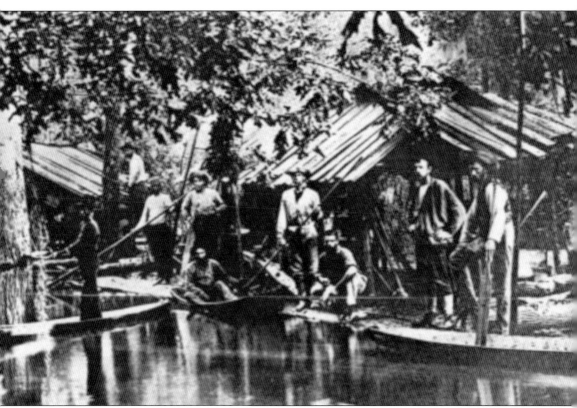

In the early 1800s, traveling from New Orleans to the Attakapas country was usually done by barge, up the Mississippi River to Bayou Plaquemine, down Bayou Plaquemine to the Atchafalaya River, and then to the various landings, such as Fausse Pointe, Cypremort, Sauvage, and Guidry, not far from Bayou Teche. Travelers brought tents and provisions for the voyage, as they had to provide whatever was necessary for their comfort. Since no traveling was done at night, the barge would be tied up toward sunset, tents pitched along the banks of the stream, and the trip resumed the following morning. In this photograph from 1888, travelers are on one of these arduous voyages through the swamps. (Courtesy Gerald Champagne.)

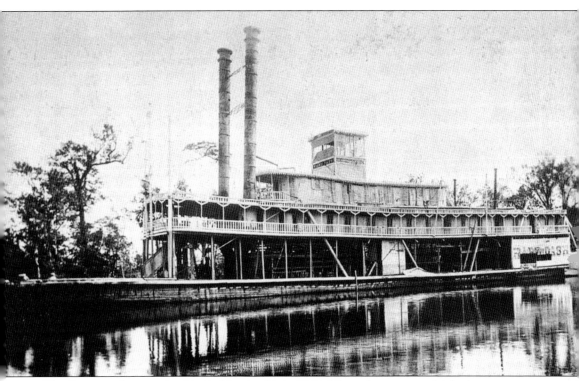

The first steamboats arrived in St. Martinville in 1840. When the water was high, they went up to Breaux Bridge and beyond. Before the steamboats arrived in St. Martinville, the route from New Orleans to the Attakapas country was up the Mississippi to Plaquemine, down Bayou Plaquemine to the Atchafalaya River, and then to the various landings along the Teche.

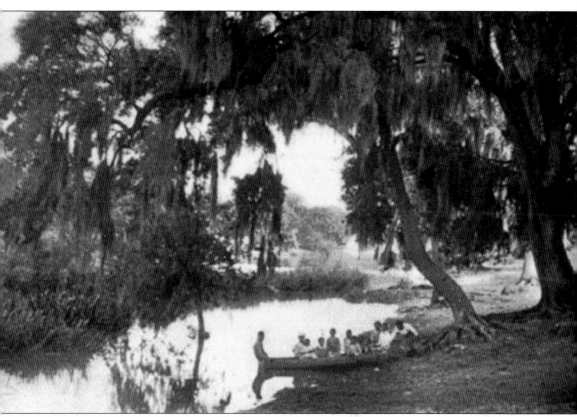

The first land grants were issued to the Acadians in 1771 in the La Manque and La Point Districts. These districts were located between the St. John Plantation northward to La Pointe (Breaux Bridge). In La Pointe, grants were issued to Charles Babineau, Michel Bernard, Jean Baptiste Broussard, Silvestre Broussard, Charles Builbeau, Joseph Hebert, Paul Thibodeau, Jean Trahan, and Francois Guilbeau. Firmin Breaux purchased his land along Bayou Teche from Solomon Malines, an agent for the Ledee estate. In 1827, Agricole Breaux gave to the administrator of schools a lot at the corner of present-day Bridge and Rees Streets, to be used for a public school. Boating and family picnics have long been a favorite pastime of residents of the Teche. Here, a family enjoys a day of canoeing along the Teche. (Courtesy Kenneth P. Delcambre.)

Two

GROWTH OF
BREAUX BRIDGE

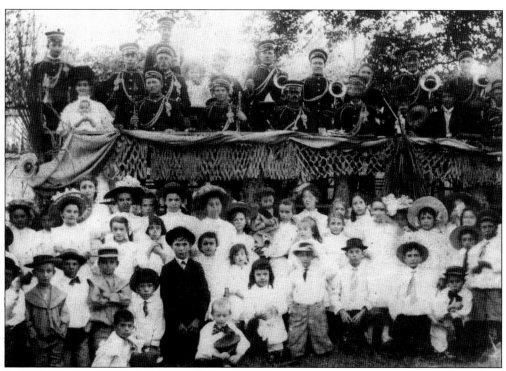

In 1890, the census recorded the population of Breaux Bridge as 654. By 1910, the population had almost doubled in size, to 1,239. By 1923, in addition to the cotton mill, the town had a soda pop factory (Breaux Bridge Ice & Bottling Works), a major car dealership (Domingues Motor), and a high school. The school, a two-story frame building on Bridge Street, opened in September 1905. It was relocated in February 1913 to the Red Brick Building, which later served as Breaux Bridge City Hall. This 1905 photograph shows residents gathered at Old City Park for an afternoon of music and festivities. (Courtesy Kenneth P. Delcambre.)

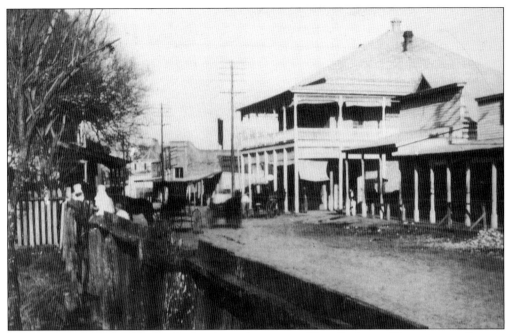

This 1915 photograph of Breaux Bridge shows the corner of East Bridge and Domengeaux Streets. The buildings seen here are the A.E. Broussard home, Breaux Bridge Bank Building, J.A. Potier Building, Frank Pellerin store, the People's Bank, and an unidentified building. (Courtesy Kenneth P. Delcambre.)

This 1917 photograph shows the Enterprise Ice & Light Company and the home of A.E. Broussard, located on East Bridge Street. Broussard owned the local country store that served as both a hardware and grocery store for the residents, selling everything from rice and coffee to horse harnesses and chicken feed. (Courtesy Kenneth P. Delcambre.)

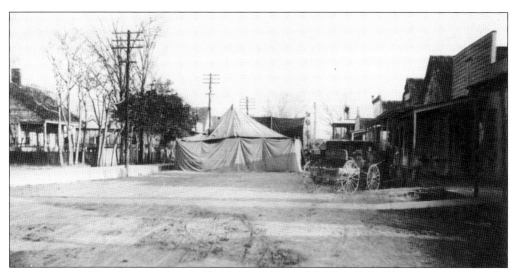

Seen here in 1917 is the street fair on North Main Street. Visible are the T.J. Lasseigne home (far left), the roofline of the Kidder Building (near center telephone pole), the Creole Drug Store, and other structures between the courthouse and Bridge Street that were part of the growing development of Breaux Bridge. (Courtesy Kenneth P. Delcambre.)

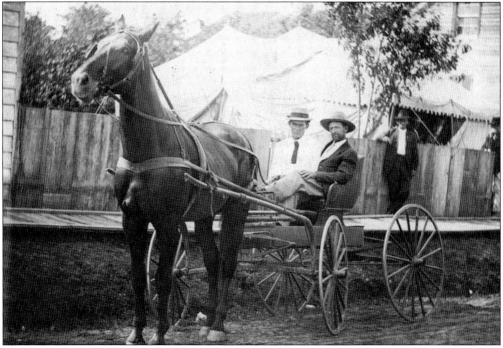

Though buggies had been surpassed by motor cars by 1910, they continued to be used in areas like Breaux Bridge. Buggies were easier to maneuver along the dirt roads that meandered through the rural prairies of southwestern Louisiana. Here, members of the Hebert family ride along North Main Street during the street fair in 1917. (Courtesy Gale Gravouilla Smith.)

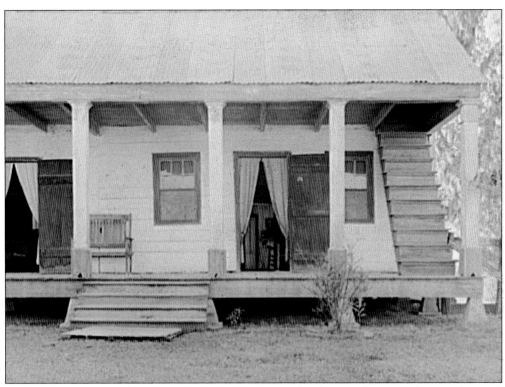

The Acadians developed new house styles. The homes they occupied in Canada were designed to withstand extreme cold, not Louisiana's wet, subtropical climate. Acadians adapted the Creole house style, which called for heavy timber construction with mud-and-moss nogging between the posts. Other basic features were a wide porch across the front, a steep roof extending over the porch, and the structure being raised above the ground on pilings to protect against flooding. This construction, with some modifications, is now considered the traditional Acadian-style house. This 1938 photograph, taken by Russell Lee near Breaux Bridge, shows a house with an outside stairway to an attic. (Courtesy Library of Congress.)

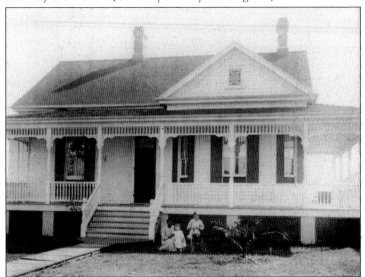

As Breaux Bridge's population grew to 1,239 in 1910, many residents built Acadian-style houses, like this one on 425 Bernard Street. Shown here in 1909 are, from left to right, unidentified, Don St. Germain (age one), and Ellis St. Germain (age three). (Courtesy Kenneth Delcambre.)

By the turn of the century, sugarcane, cotton, corn, and rice were the main crops. Cane is planted right up to the edge of the road in many areas, growing lush, green, and high by late summer. It is still one of the main crops in the area. Farmers supplemented their incomes by growing and selling vegetables such as cabbage, onions, snap beans, okra, red peppers, and potatoes. (Courtesy Library of Congress.)

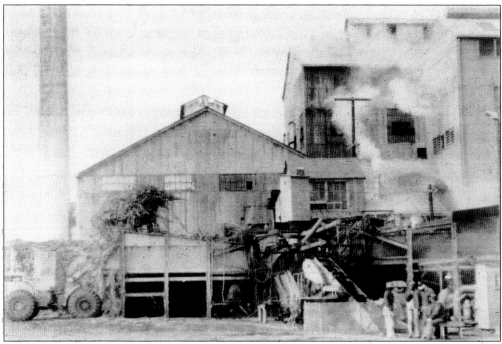

Jesuit priests brought the first sugarcane to South Louisiana in 1751. Étienne de Boré produced the first successful sugar crop. Established in 1938, the Breaux Bridge Sugar Cooperative was the world's first high-speed sugar mill. In 1993, the firm merged with the St. Martin Sugar Cooperative to form the Louisiana Sugar Cane Cooperation, located in St. Martinville, Louisiana. (Courtesy Kenneth Delcambre.)

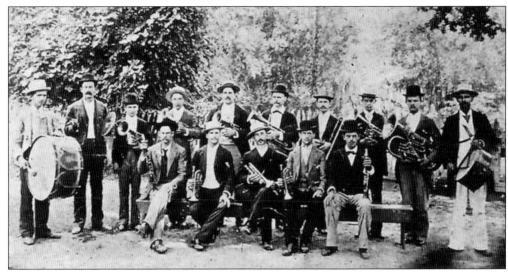

As it is today, music was an integral part of the Acadian community at the turn of the century. Here, members of the Breaux Bridge Brass Band pose for a photograph. The band's music is associated with the dance halls that were popular with families on Saturday nights. There was very little recreation available for farm families. After a week of hard work, they looked forward to the Saturday night dances. (Courtesy Kenneth P. Delcambre.)

The Champagne family posed for this photograph in 1904. Denis Champagne and his wife, Modeste Patin Champagne, were farmers. The entire Champagne family lived in adjoining farms. Denis was the son of Leo Pierre Champagne, who served in the Civil War in Company E, Consolidated 18th Regiment & Yellow Jackets Battalion. (Courtesy Gerald Champagne.)

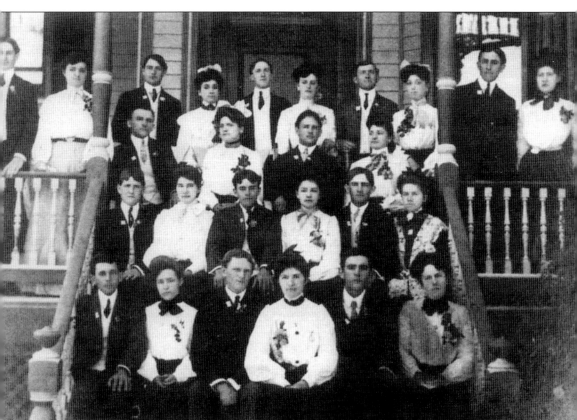

Shown here in 1905 are members of the Breaux Bridge "Euchre Club." They were descendants of the first settlers. They are, from left to right, the following: (first row) Felix Broussard, Angelle Landry, George Richard, Denise Hollier, Alexis Broussard, and Loulou Mills; (second row) Louis Champagne, Elmire Broussard, Jules Hardy, Editha Ledoux, Edward Resweber, and Clemence Hardy; (third row) Albert Resweber, Camelia Champagne, Rene Resweber, and Eloise Broussard; (fourth row) Frank Babin, Yola Hebert, Edmond Resweber, Caloute Babin, Claude Rees, Corinne Mills, George Chamagne, Laurence St. Germain, Henry Mills, and Candide Rees. (Courtesy Kenneth Delcambre.)

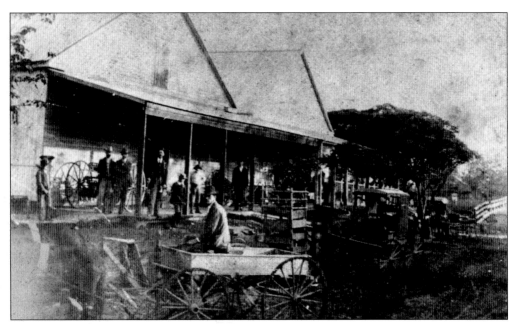

The downtown area of Breaux Bridge had residences interspersed among the commercial buildings. A.E. Broussard's store occupied a large two-story building on East Bridge Street in 1905. It was a general mercantile store that sold everything from clothing to furniture, produce to farm equipment. Such businesses were among the various stores located in downtown Breaux Bridge that were the equivalent of the large box stores of today. (Courtesy Kenneth P. Delcambre.)

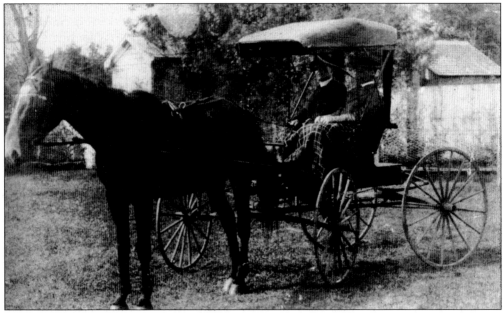

Fr. August Michel Rochard (left) sits in a horse-and-buggy with his adopted son, Dr. Laurent Broussard, DDS, as they ride through Breaux Bridge in 1915. Father Rochard was from Neuvyen-Maugues, France, and served as the pastor of St. Bernard Parish from 1908 to 1923. He is credited with the foundation of what became the St. Francis of Assisi Catholic School and with bringing the Sisters of the Holy Family from New Orleans to administer the school.

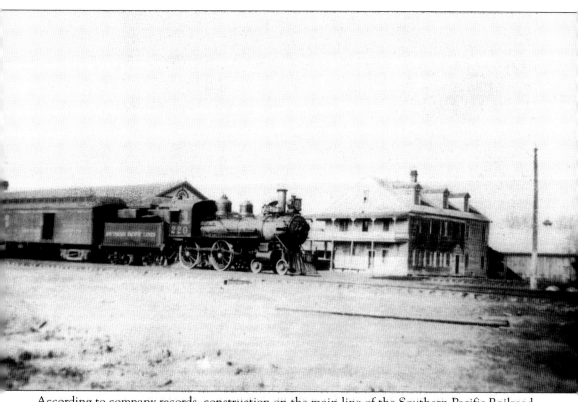

According to company records, construction on the main line of the Southern Pacific Railroad began at Algiers, across the Mississippi River from New Orleans, in 1852. The line from Cade to St. Martinsville was completed in 1882, and to Breaux Bridge in 1895. This photograph of the Southern Pacific line was taken in 1912. The flood of 1927 washed away the bridge across the Atchafalaya, and service was discontinued. Later, service from Breaux Bridge to St. Martinville and Port Barre was discontinued. Construction of Interstate Highway 10 began in the 1950s, connecting Breaux Bridge to Lafayette to the west and Baton Rouge to the east. (Courtesy Kenneth P. Delcambre.)

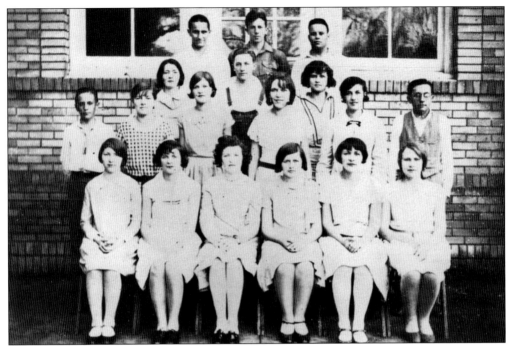

The Breaux Bridge High School class of 1928 included, from left to right, (first row) Melba Broussard, Anne Castille, Beatrice Edmond, Odillia Broussard, Maxie Nereaux, and Bella Castille; (second row) J.S. Badon, Fabriola Hollier, Lillian Castille, Yuline Trahan, Marian Mills, and Camile Guidry; (third row) Cecile Angelle, Patrick Pellerin, and Druscilla Wiltz; (fourth row) James Begnaud, Ray St. Germain, and James Thevent. (Courtesy Kenneth Delcambre.)

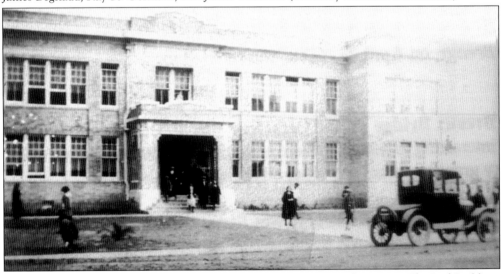

The first Breaux Bridge High School opened in 1905 at 348 West Bridge Street. The Red Building, shown in the above c. 1914 photograph, was constructed in 1913 at the corner of Main and Martin Streets, facing City Park, at a cost of $20,000. The White Building was constructed in 1922 for $85,000. The old Breaux Bridge High School was destroyed by fire in 1975. Located three miles out in the country, the new school was constructed in 1972 and was dedicated on April 21, 1974. (Courtesy Kenneth P. Delcambre.)

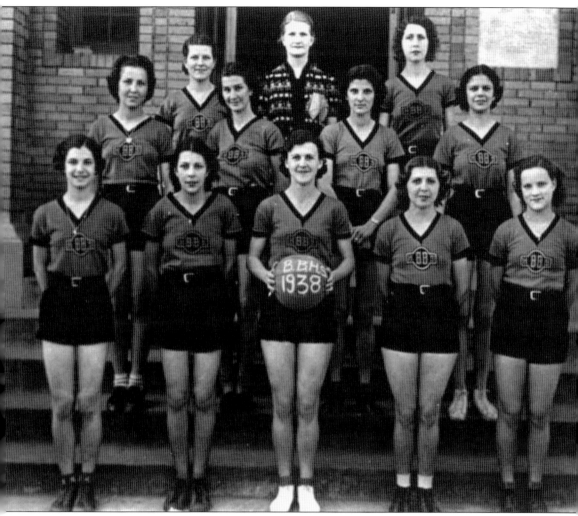

By 1938, the high school had several sports teams, including the Breaux Bridge basketball team. The Fighting Lady Tigers were coached by Edwina Crowder Hebert (third row, center). (Courtesy Kim Dever Thibodeaux.)

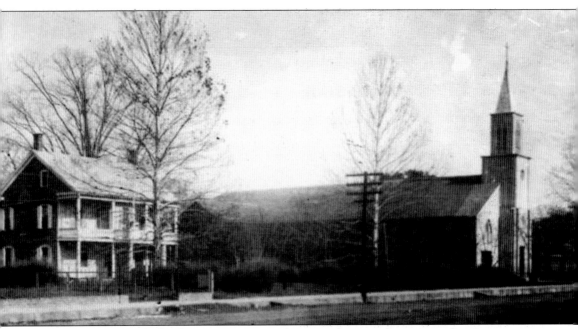

The Acadians made the decision to come to Louisiana because the main spoken language was French and the predominant religion was Catholicism. The first settlers along Bayou Teche had to do without ministrations of their church except on those rare occasions when a French missionary from Natchitoches or Point Coupee would venture into the area. After the church in St. Martinville was established in 1765, Fr. Alexander Viel ministered to the entire region. He would periodically visit the various settlements within that region and hold services, baptize newborns, and celebrate marriages. During the 1840s, services were usually conducted in private homes. In 1847, St. Bernard Parish was established on the corner lot now occupied by the Farmers & Merchants Bank. Fr. J. Zeller, Francophone native of the Alsace-Lorraine region, was assigned to St. Bernard. He remained at the church until 1848. On Ash Wednesday, in March 1848, Fr. J. LeGrand assumed the duties as pastor of St. Bernard Church until 1851. Several pastors served the church from 1851 until 1857, when Fr. Jean Honore Dubernard, a young French priest, was installed as pastor. His first act was to erect a suitable, spacious, and permanent church, the St. Bernard Catholic Church and Rectory (shown here). In later years, the church established a school and a convent by the Sisters of Perpetual Adoration. In addition to St. Bernard's, Breaux Bridge has another Catholic church, St. Francis of Assisi, which serves the African Americans of the community. It was established in 1923 by Fr. James Albert. (Courtesy St. Bernard Church.)

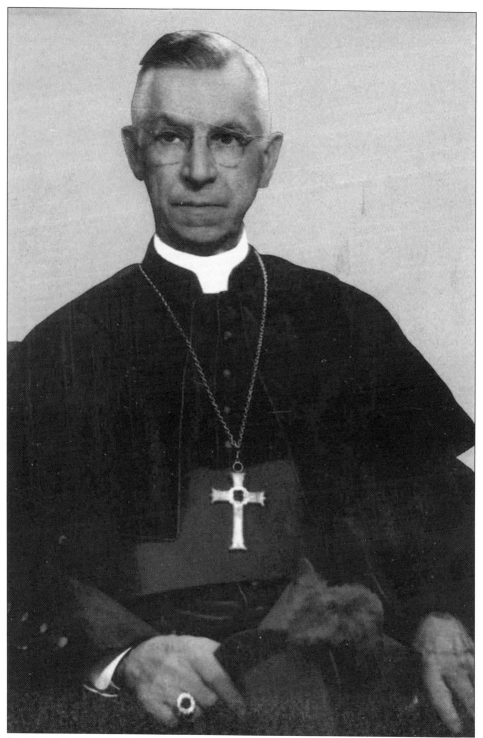

Bishop Jules B. Jeanmard, the first native priest of Breaux Bridge, was installed in 1918 as the first Bishop of Lafayette. He came back to his native diocese after serving as chancellor and administrator of the Archdiocese of New Orleans.

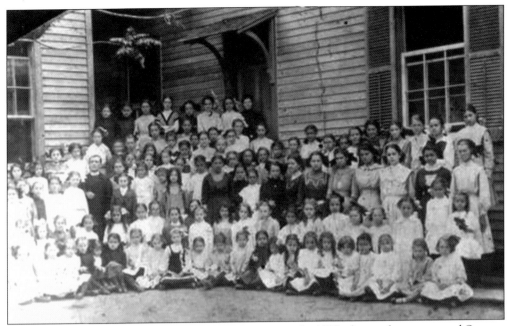

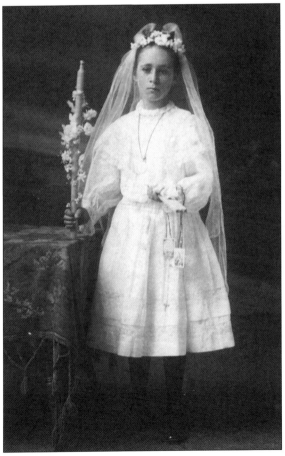

In 1905, the newly constructed St. Bernard School opened as a boarding school that taught classes up to the eighth grade. The three-story building housed classrooms, dormitories for boarders, nuns' quarters, and a chapel. Its first graduates were Lavina Perlerin and Bertha Barras in 1910. (Courtesy Kenneth Delcambre.)

The activities of the Acadian settlers revolved around the church. First Communion is the colloquial name for a person's first reception of the sacrament of the Holy Eucharist. It is celebrated with large family gatherings, and special clothing is usually worn. This 1911 photograph shows the First Communion of Editha Guidry Hebert, who is wearing her Communion dress. (Courtesy Kenneth Delcambre.)

Three

CENTENNIAL CELEBRATION

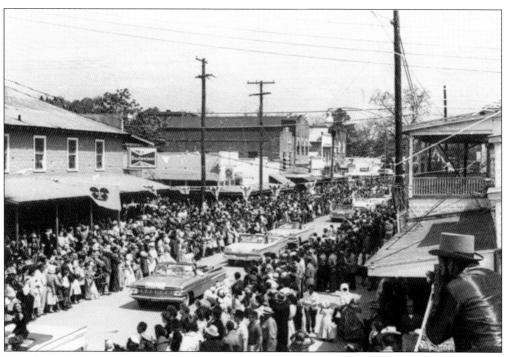

In 1958, district judge A. Wilmot Dalferes of Lafayette discovered the 1859 Act of Incorporation of Breaux Bridge. Upon discovery of these papers, civic, religious, and fraternal group leaders organized and began planning an observance of the centennial of the incorporation. The people of Breaux Bridge gathered on April 10, 11, and 12, 1959, to celebrate. Most of the city's population of 5,000 participated in the festivities. Crowds of over 75,000 were estimated to have attended the three days, with former residents and descendants of the original settlers coming from various parts of Louisiana and Texas.

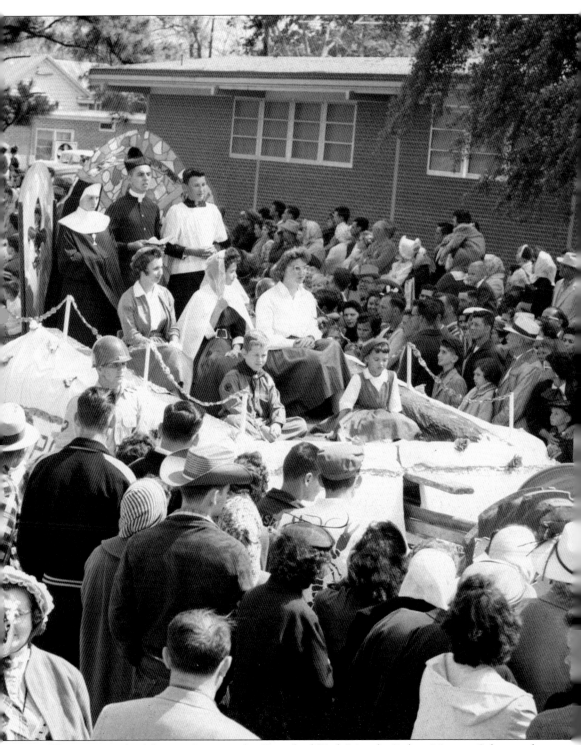

The centennial celebration began with a Pontifical High Mass by Bishop Maurice Schexnayder of St. Bernard Catholic Church on the morning of April 10, 1959. This was followed by a parade down Main Street led by Fr. Paul Patin, seated on the float shown here.

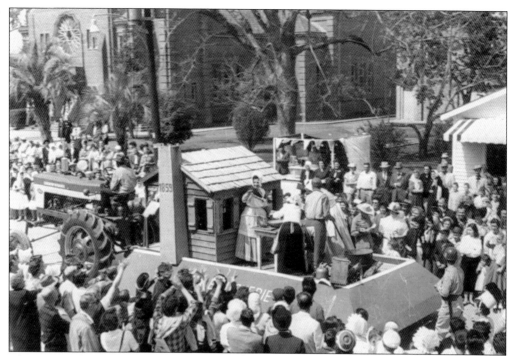

The mass was followed by a full program of festivities on Main Street, including two street parades, one by the white community and one by members of the African American community. On the float seen here is an Acadian-style house with sausages hanging on a line in front.

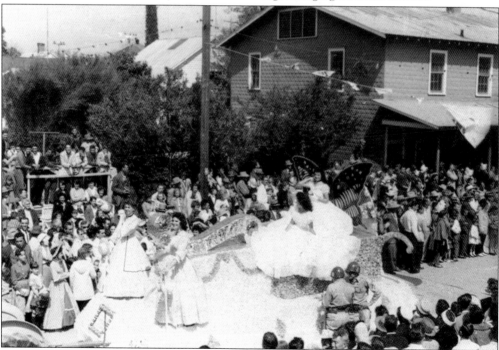

Dianne Domingues Townsend was chosen as the queen of the centennial celebration. Here, she waves to the crowd as the queen's float travels down Main Street.

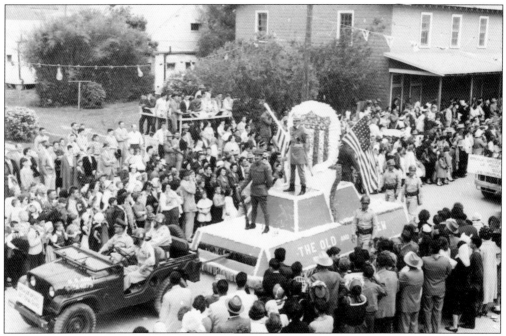

This float was in honor of the veterans of World War II. The residents of Breaux Bridge have a long history of participation in the wars of the United States. Firmin Breaux was among the early settlers who answered the call to join the expedition that captured the British forts in the lower Mississippi Valley in the American Revolutionary War. During World War II, over 90 men from Breaux Bridge participated, serving in the various branches of the armed forces.

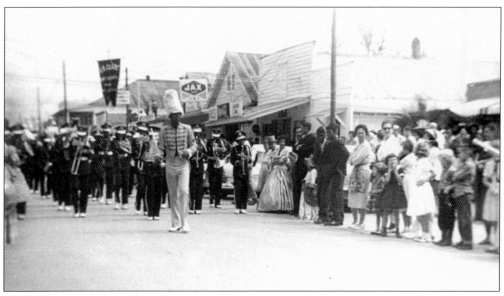

High school bands from throughout the southern region of Louisiana participated in the three-day celebration. The George Washington Carver High School Band was one of the groups that came from New Orleans to march in the parades.

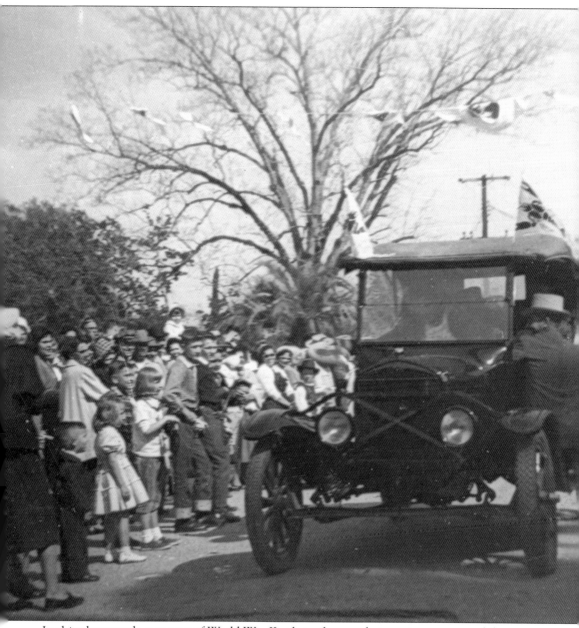

In this photograph, veterans of World War II ride in the parade in a vintage automobile as part of the celebration.

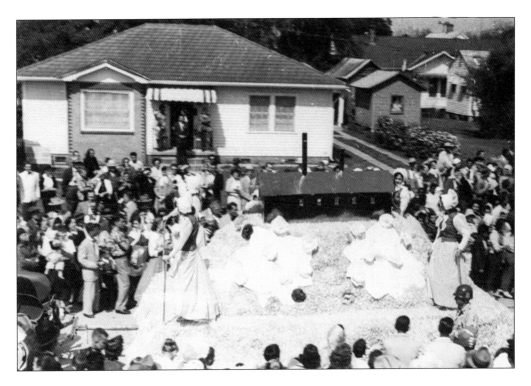

Floats in the parade celebrated the town's accomplishments, such as the sugarcane mill (above) and the first school (below). The parade traveled down Main Street, past St. Bernard Catholic Church and Rectory, which was built in 1857.

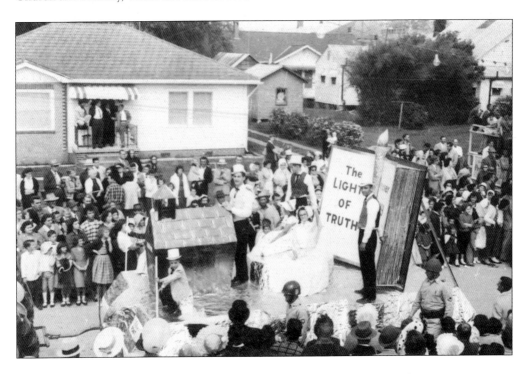

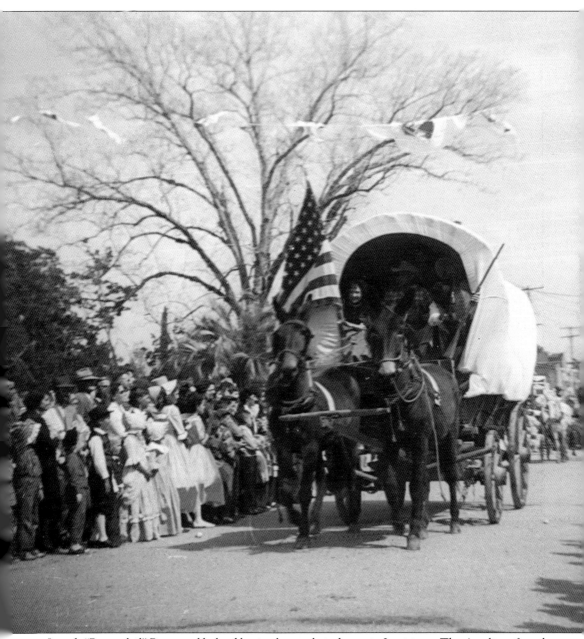

Joseph "Beausoleil" Broussard helped begin the cattle industry in Louisiana. The Acadians found the lush vegetation of the unfenced, wide vistas of the Gulf Coast prairies ideal for raising cattle and horses. Alphé A. Broussard brought a herd of full-blooded Charolais cattle from Mexico to Louisiana, and this became the foundation herd of Charolais cattle in North America. The census of 1766 records that the district had five cattle ranches with 15,000 head of cattle. In 1773, Amant and Pierre Broussard, assisted by eight or nine drovers, began moving small herds of cattle to New Orleans. By 1774, Firmin Breaux's branding iron was registered, and by 1786, he was one of the largest property owners in Teche country. A wagon representing the cattle-herding of the early settlers was part of the parade in 1959.

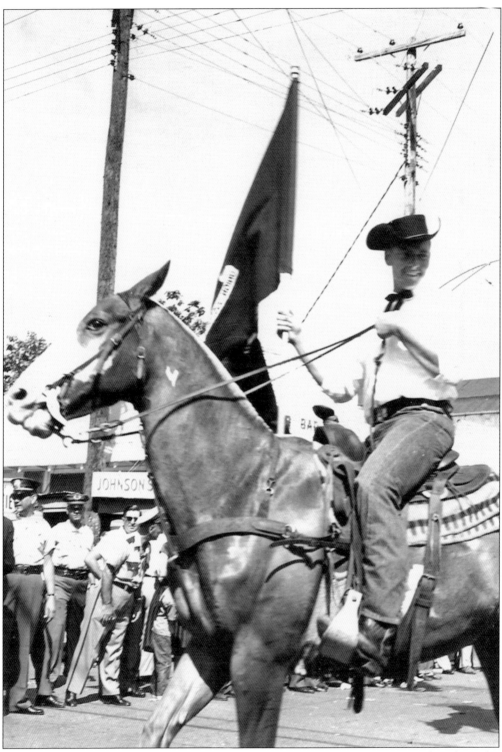

In this image, Richard Green, on his horse, Toyboy, carries the Louisiana state flag along the parade route on Main Street.

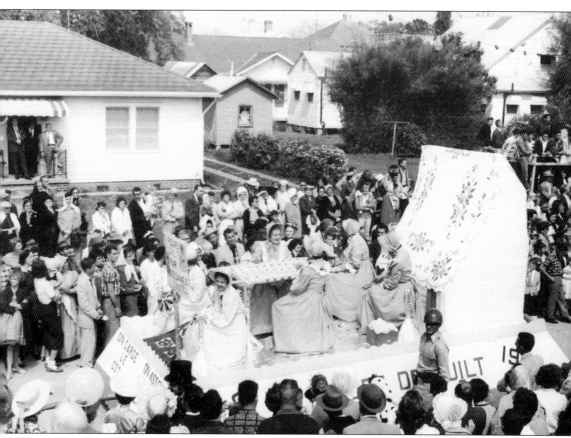

In Nova Scotia, the Acadians' winter clothing had been made from wool produced by the sheep they raised and spun on household spinning wheels and looms. However, sheep were scarce—and expensive—in Louisiana. The Acadians first grew small quantities of flax for home consumption, but they discovered it would not grow well in semitropical Louisiana, so it was discarded. The settlers quickly mastered cotton cultivation, harvesting, and processing. Acadians on both sides of the Atchafalaya utilized pre-Whitney cotton gins to remove seeds and facilitate spinning as early as 1772. By 1810, the principal cottage industry became the production of cotton cloth by the women of the Teche Valley settlements. This industry was displayed in the parade on a float depicting quilters.

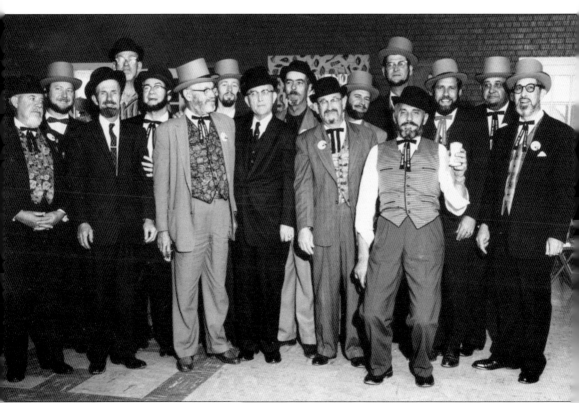

Many of the men from Breaux Bridge grew beards and wore costumes from 1859. Shown here are, from left to right, (first row) George Champagne, Dalton Thiodeaux, A. Mathieu, Louisiana state representative Bob Angelle, Constant Guidry, and Thomas Roberts; (second row) Raymond Castille, Dewey Barras, Martin Blanchard, Jeffrey Vanguahn, Ollie Bourque, Woodrow Marshall, Roy Lasseigne, Louis Kern (Mayor), Stanley Angelle, and Harris Perriou.

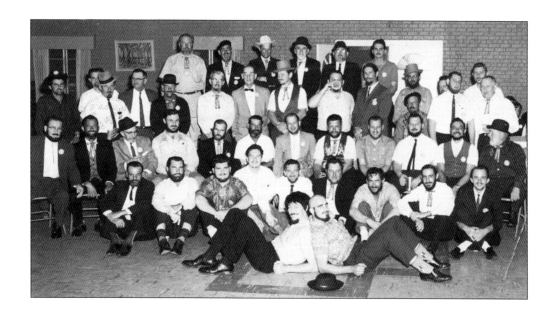

In 1959, most of the men (shown above) in town grew beards in honor of the first Acadians that settled in Breaux Bridge. Some, however, protested and refused to grow facial hair. They were "arrested," as seen below.

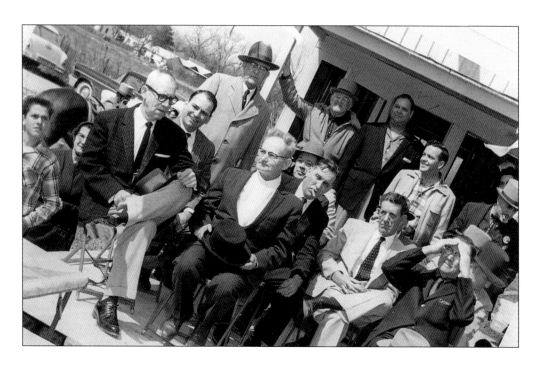

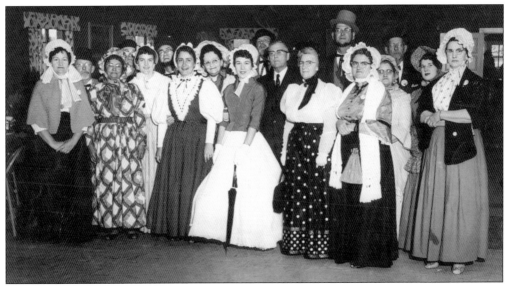

Based on research, it was determined that women of Breaux Bridge in 1859 wore handwoven skirts, chemises, and shawls. These women in 1959 dressed in clothing that they believed the women of a century ago would have worn.

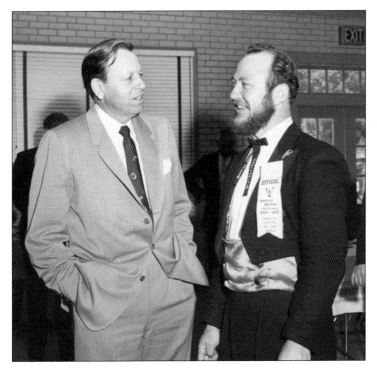

James Houston "Jimmie" Davis (far left) served two nonconsecutive terms as governor of Louisiana (1944–1948 and 1960–1964). Davis, who also sang, is a member of the Country Music Hall of Fame and the Louisiana Music Hall of Fame. He was one of the many politicians who attended the celebration. Here, he converses with Councilman Raymond Castille (right). Castille was one of the main organizers of the centennial celebration.

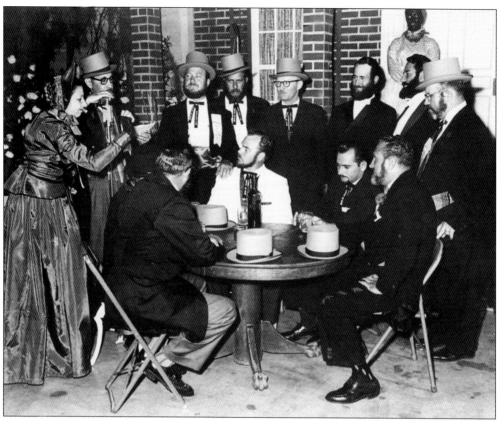

Wearing 1859 attire, townspeople gathered for this photo opportunity. Among the group were Mrs. Paul Mennet, Mayor Louis Kern, Raymond Castille, Tommy Hughes, Kit Castille, Louis Batch, Erol Hollis, Irby Landry, and Paul Juliard Jr.

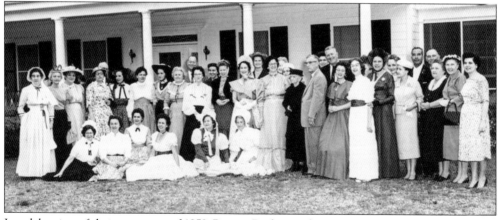

In celebration of their ancestors of 1859, Breaux Bridge residents pose in contemporary attire for a group photograph as part of the celebration. State representative Bob Angelle is among the residents gathered here.

Those who dressed in 1859 attire included the Victor family (above). In the photograph to the left are Emilie and Sheldon LeBlanc with their daughters, Mary and Katherine.

Almost all of the 5,000 residents of Breaux Bridge participated in the festivities for the centennial celebration. Even the children dressed in 1859 attire.

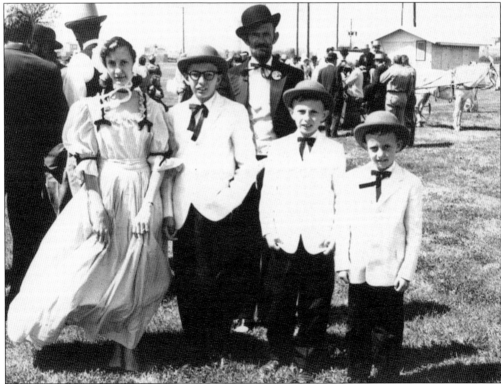

This photograph shows members of the Dalton Thibodeaux family dressed in period attire for the celebration.

Sidney and Marianne Delcambre
Broussard participate in the celebration.

Carl and Renella Simon are seen here
during the celebration. Carl is the
owner of Simon Pharmacy, which
opened in 1957 and is still located on
Main Street.

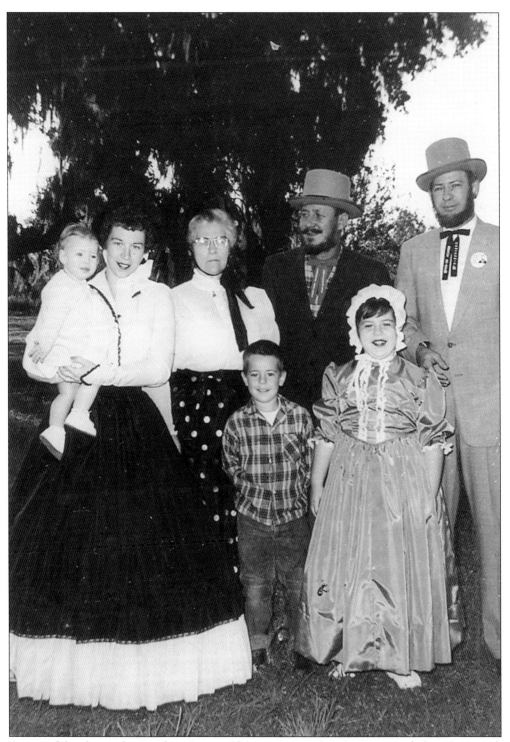

Broussard family members Barbara Broussard, Mary Ann Delcambre Broussard, Greg Broussard, Debbie Broussard, and Sidney Broussard were among the townspeople who dressed in 1859 attire.

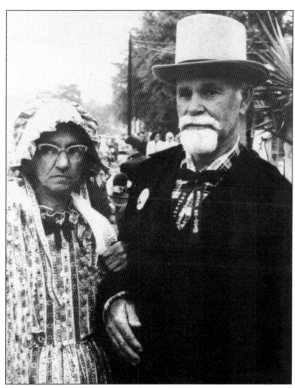

Bertha and Timothe Landry pose for a photograph at the celebration. Timothe was born in Breaux Bridge in 1892. (Courtesy Janet Boudreau Landry.)

Contestants for queen of the centennial included, from left to right, Emily Hebert, Rita Thibodeaux, Diane Townsend, Nelma Hebert, Irene Morrogh, Elaine Le Blanc, and Barbara Harrington.

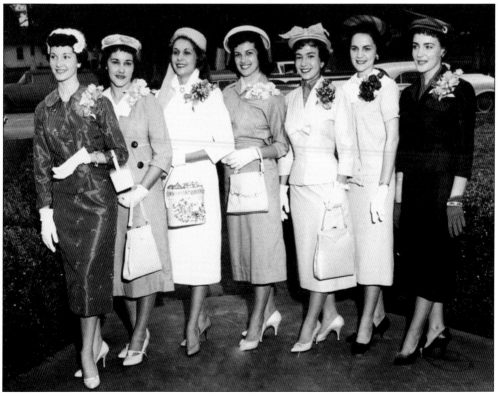

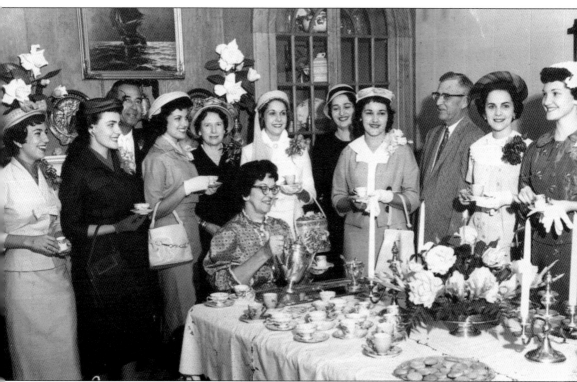

A coffee reception was held at the home of Speaker of the Louisiana House of Representatives Robert Angelle (third from right) and his wife, Madge Germaine Begnaud Angelle (pouring tea). The reception honored the contestants for queen. Robert "Bob" Angelle (August 26, 1896–December 22, 1979) was a businessman and politician from Breaux Bridge. He was a town council member and mayor of Breaux Bridge in the early 1920s and was the Speaker of the Louisiana House of Representatives from 1957 to 1960, the last term of Gov. Earl Kemp Long. He sponsored a bill that declared Breaux Bridge "the Crawfish Capital of the World." He is interred in St. Bernard Cemetery.

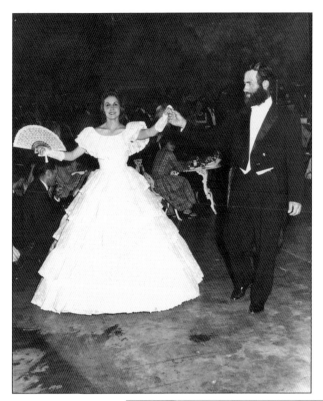

Dianne Domingues Townsend was chosen as the queen for the centennial celebration. She was presented at a coronation ball at the National Guard Armory by Carlton "Kit" Castille.

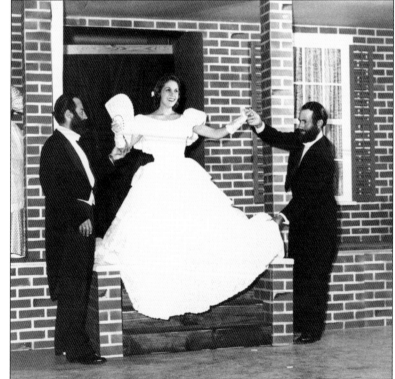

Dianne Townsend is presented at the coronation ball by Kit Castille (left) and Bob Angelle. Townsend was chosen from among 30 beautiful and talented girls in the community.

Raymond Castille places the crown on top of Queen Dianne Townsend's head during the coronation ball.

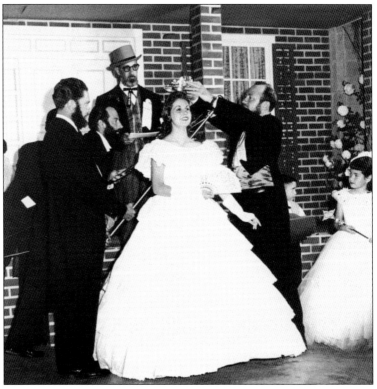

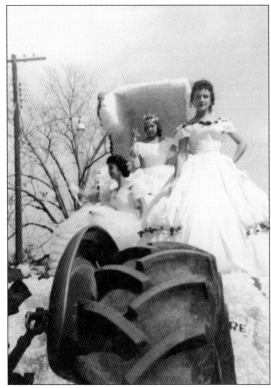

Diane Townsend waves to the crowd on the queen's float during the parade. The estimated attendance of the celebration was over 75,000, including people from surrounding areas in Louisiana and Texas.

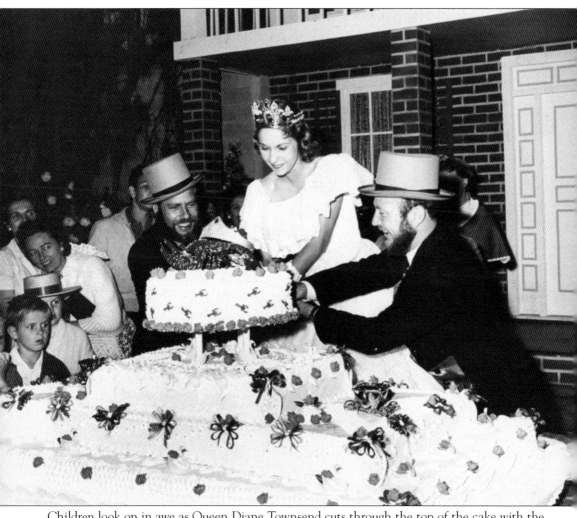

Children look on in awe as Queen Diane Townsend cuts through the top of the cake with the assistance of Mayor Louis Kern (left) and Councilman Raymond Castille.

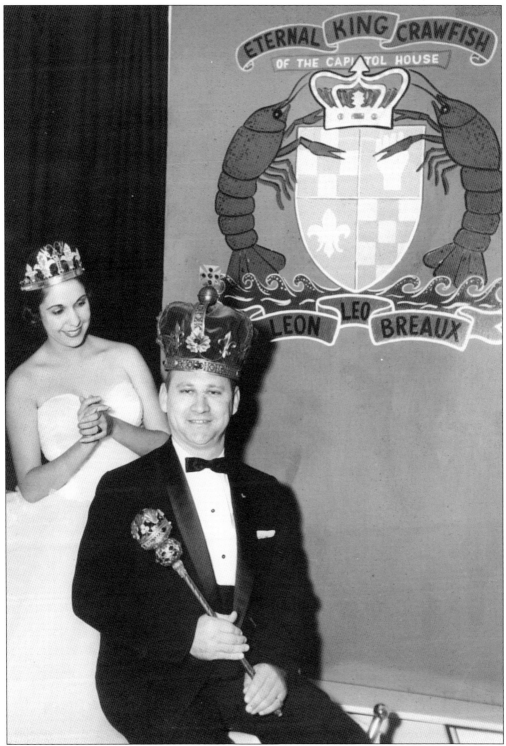

Queen Diane Townsend crowns the "Eternal King Crawfish," Leon Breaux. He became the spokesperson for the Crawfish Festival, promoting it throughout the South.

Sunday's activities included a political rally that attracted candidates for state public office at the Breaux Bridge High School gym. Among those attending were Gov. Earl K. Long (far right), the 45th governor of Louisiana for three nonconsecutive terms—1939 to 1940, 1948 to 1952, and 1956 to 1960. Long was in Breaux Bridge to speak at the gubernatorial campaign kickoff political rally that was held in conjunction with the 1959 Breaux Bridge Centennial.

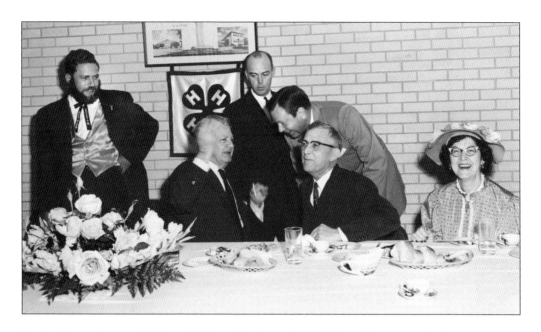

In the above photograph, Rep. Bob Angelle (seated at right) speaks to Gov. Earl K. Long. Gov. Jimmie Davis is leaning in. Also attending the rally were Angelle's wife, Madge (far right), and Breaux Bridge mayor Louis Kern (far left). In the below photograph, Governor Long shakes hands with a member of the audience.

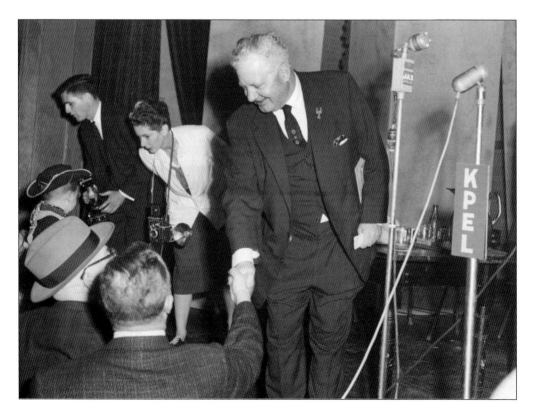

"Laissez le bon temps rouler"

BREAUX BRIDGE FESTIVAL RULES

1. Language — English is understood, Cajun is preferred.
2. Natives. — All friendly.
3. Photographs — No more than 500 colored pictures may be taken of any one historic spot or smiling native.
4. Souvenirs — 2000 pound limit.
5. Legal tender — Dollars are still popular in Breaux Bridge (and go a long way). No limit to amount brought in.
6. Food — Hot, but none better, especially the crawfish.
7. Water — No need to bring bring any. It is not drunk in our town. Will furnish some for bathing.
8. Length of Visit —?— because qui boit l'eau de Teche, reviendra assurement.
9. Don't step on our crawfish, we eat them.

During the celebration, a time capsule was buried in front of St. Bernard's church, to be opened in 2059. This was followed by the noon serving of crawfish dinners, the Horse and Buggy Parade, a civic reception for dignitaries, the cutting of the centennial cake, and, finally, the Bal des Vieux. Publicity gimmicks reported to have been used included organizations such as Les Braves Barbes and its woman's auxiliary, Les Belles, who gave goodwill tours to neighboring towns; the making and selling of centennial souvenirs; the displaying of artifacts and memorabilia from the 1850s by stores; the use of centennial automobile plates and passports; and the wearing of costumes from 1859.

PASSPORT TO
BREAUX BRIDGE, LOUISIANA
CRAWFISH CAPITAL OF THE WORLD

This is to certify that

is allowed to penetrate our crawfish net curtain and enjoy honorary citizenship during our CRAWFISH FESTIVAL MAY 4 & 5, 1974.

Issued by: *Robert X Suur*

President, Crawfish Festival Assoc.

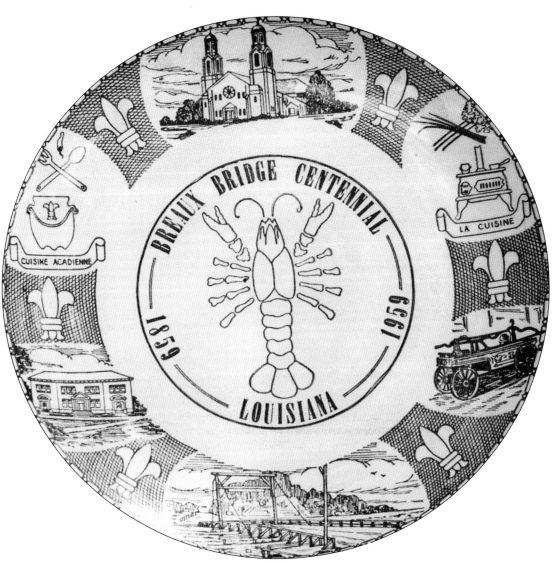

Commemorative plates were made to celebrate the centennial. St. Bernard Catholic Church, Breaux Bridge High School, the bridge, and the King Crawfish were featured on this plate marking the centennial. (Courtesy Janet Boudreau Landry.)

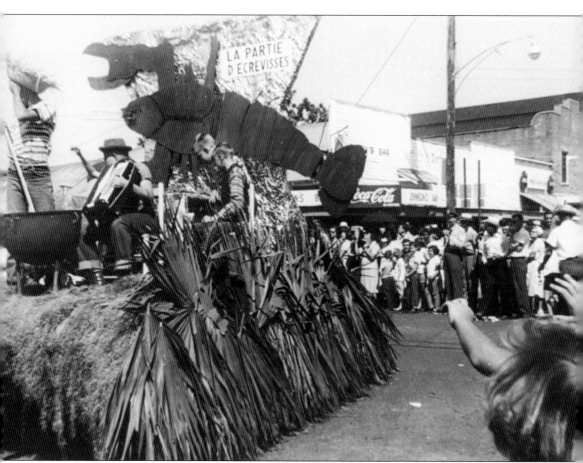

How did the crawfish gain such prominence in the cuisine of the Cajun culture? Mrs. Charles Hebert is credited with being the first to put crawfish on a menu in the early 1920s. "Tante Naie," as she was known, served meals country-style at a 20-foot-long dining table at the Hebert Hotel. She is credited with creating such crawfish dishes as crawfish bisque, stew, and patties. She also served all the crawfish one could eat for 25¢. Word of her cooking spread, and people came from far and near to eat at her table, including Pres. Herbert Hoover and Congressman Robert Mouton. Thousands of pounds of crawfish are served at the festival in about every conceivable way: boiled crawfish, fried crawfish, crawfish etouffee, crawfish dogs, crawfish jambalaya, crawfish boudin, crawfish pies, crawfish bisque, and crawfish gumbo. This is the parade float that celebrated Monsier L'Ecrevisse in the 1959 centennial celebration.

Four

CAJUNS, QUEENS, AND CRAWFISH

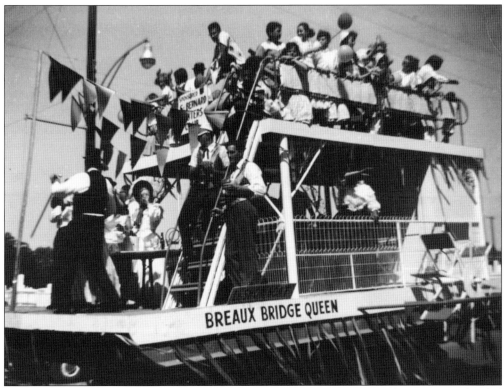

Due to the success of the centennial celebration, the Breaux Bridge Festival Association decided to continue a yearly festival honoring "Monsieur L'Ecrevisse." Thus, the first Crawfish Festival began in 1960 and has been held almost every year in the spring. The parades for the early festivals were conducted on the water of Bayou Teche.

Emmaline Hebert Thibodeaux was the first Crawfish Festival queen in 1960. She also served as the queen of the Crawfish Festival in 1961. (Courtesy Emmaline Hebert Thibodeaux.)

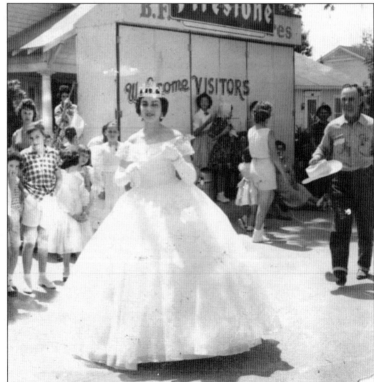

Queen Emmaline Hebert said she worked that morning at her father's store, then got dressed in her gown, donned her crown, and went to the parade. (Courtesy Emmaline Hebert Thibodeaux.)

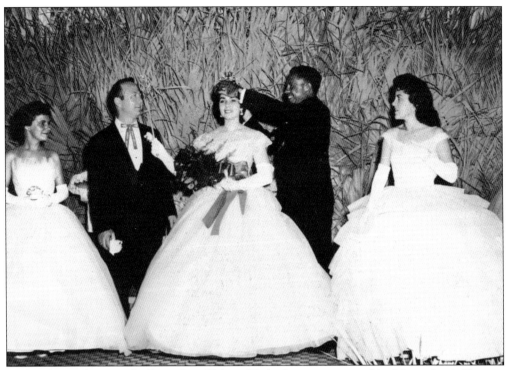

In the above photograph, Emmaline Hebert Thibodeaux is crowned by Mayor Louis Kern as the first Crawfish Festival queen. Below, she is on the queen's float as part of the 1960 parade. (Courtesy Emmaline Hebert Thibodeaux.)

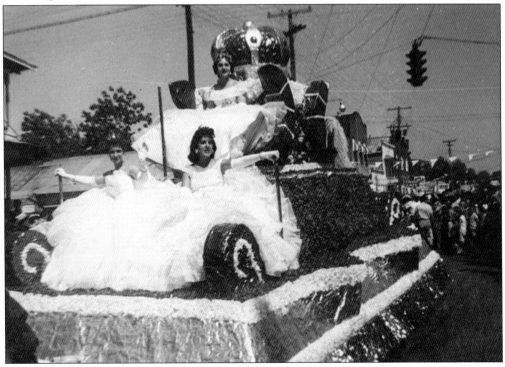

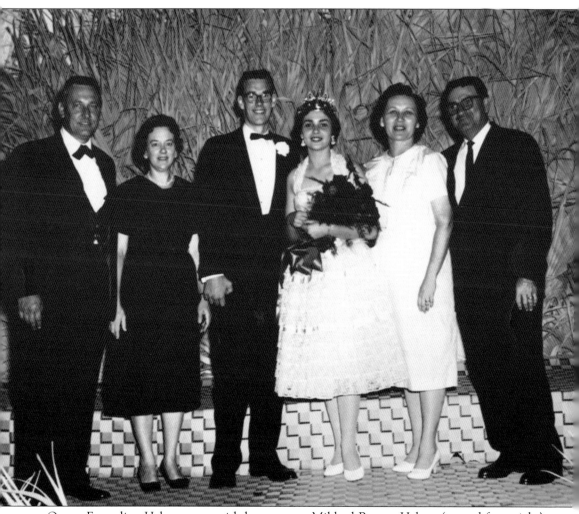

Queen Emmaline Hebert poses with her parents, Mildred Breaux Hebert (second from right) and John D. Hebert (far right). Emmaline wrote that the most memorable highlight of her reign happened in Washington, DC, where, she said, "I was given the honor of shaking the hand of president John F. Kennedy in the cabinet room." She also traveled to New Orleans for the 26th and 27th Sugar Bowl games. (Courtesy Emmaline Hebert Thibodeaux.)

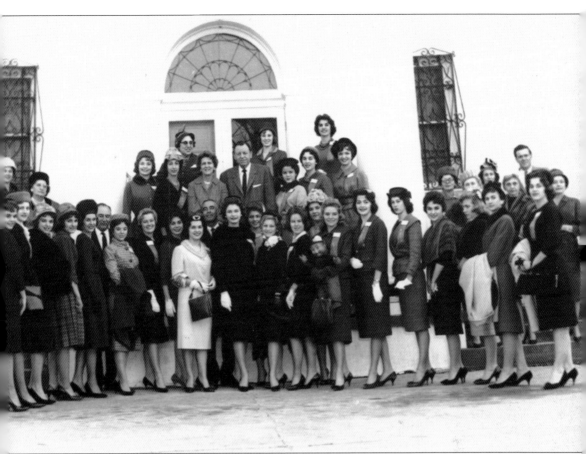

Emmaline Hebert (first row, in white suit, with crown), with Louisiana governor Jimmie Davis (center in the back row), poses with a delegation of citizens from Breaux Bridge. The delegation traveled to the Capitol to hear the famous Speaker of the House, Samuel Rayburn. Hebert remembers introducing herself to a girl named Lynda Johnson, only to discover later that she was the daughter of Vice Pres. Lyndon Baines Johnson. (Courtesy Emmaline Hebert Thibodeaux.)

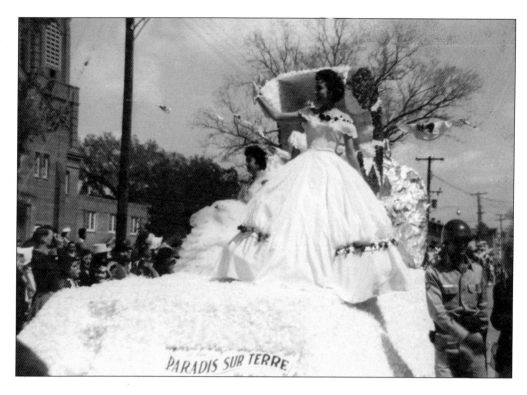

Crawfish Queen Emmaline Hebert waves to the crowd from the queen's float during the first Crawfish Festival in 1960.

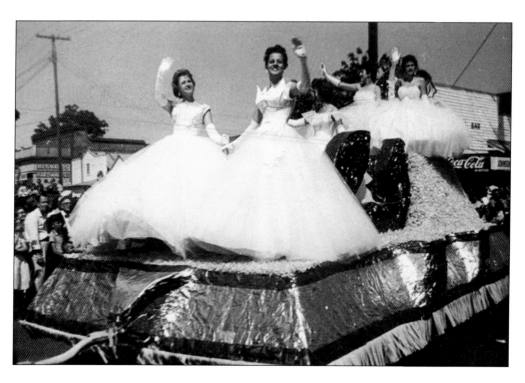

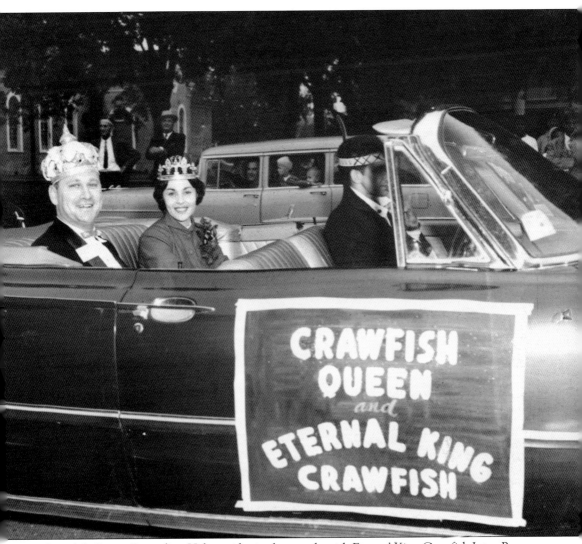

Crawfish Queen Emmaline Hebert rides in the parade with Eternal King Crawfish Leon Breaux, who was the unofficial spokesperson for the festival.

These photographs show the Victor family participating in the boat parade during the 1960 Crawfish Festival.

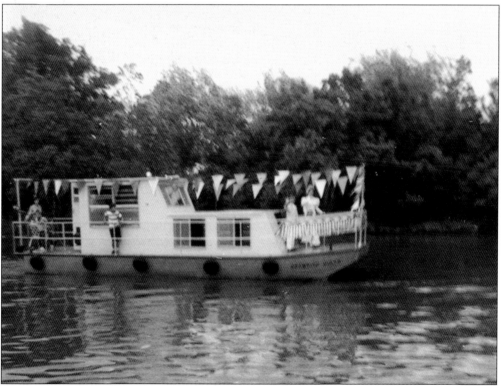

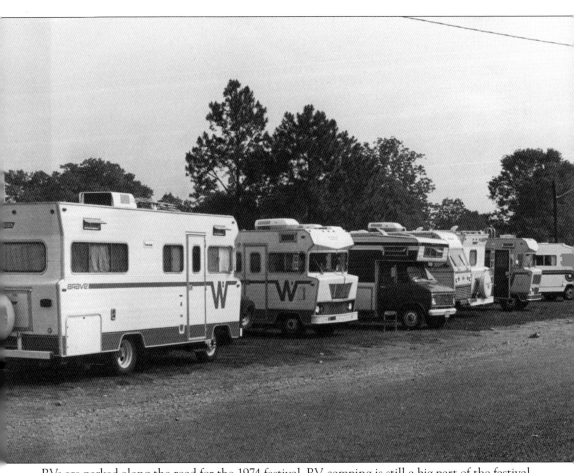

RVs are parked along the road for the 1974 festival. RV camping is still a big part of the festival, as people from all around the country travel to attend the three-day event.

Susan Irwin,
1974 Crawfish
queen, waves
to the crowd
on the queen's
float (left).
In the below
photograph,
Irwin is
accompanied
by Christine
Guidry
(left) and
Susan Gonzales.

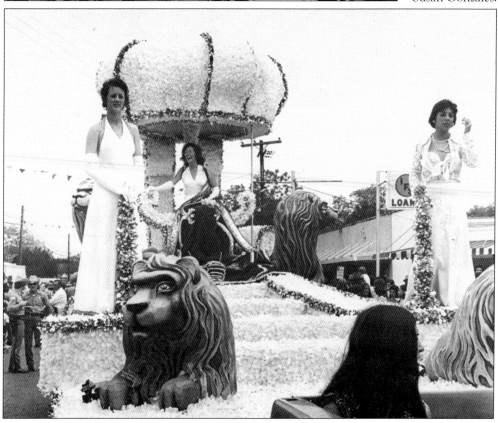

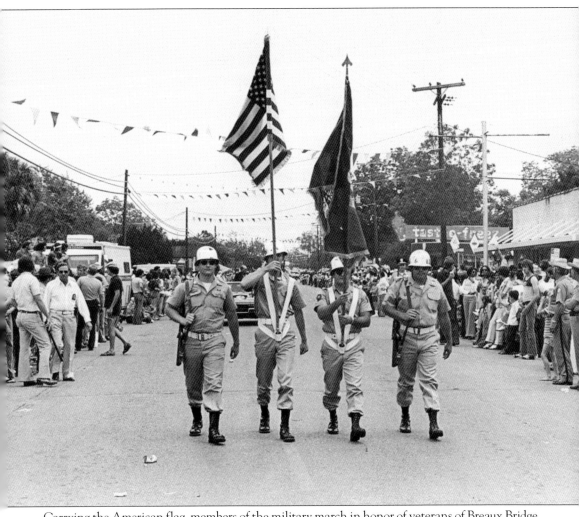

Carrying the American flag, members of the military march in honor of veterans of Breaux Bridge. Over 90 residents of Breaux Bridge served in World War II. A memorial for the servicemen is in City Park.

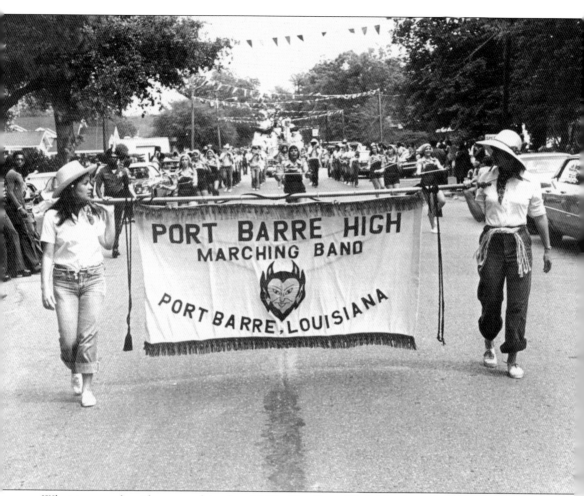

What is a parade without marching bands? The Port Barre High Marching Band was part of the 1974 Crawfish Festival.

These photographs show high school bands marching in the 1974 Crawfish Festival.

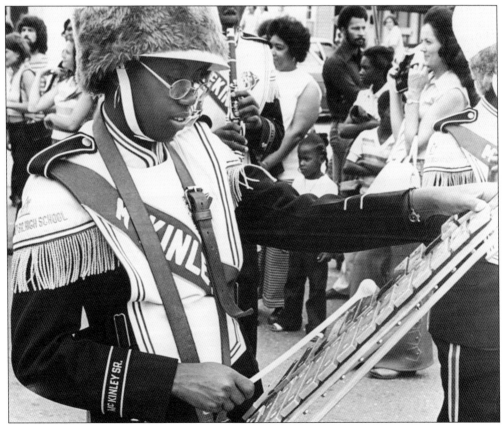

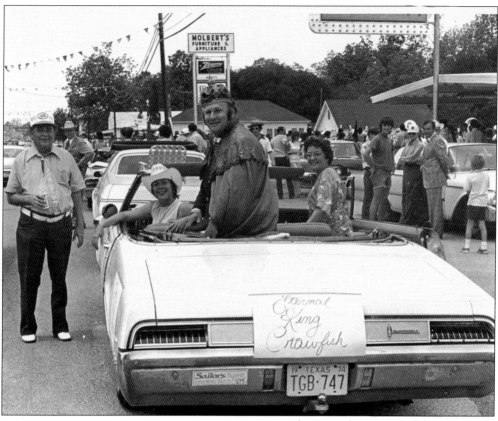

The Eternal King Crawfish is pictured here during the 1974 Crawfish Festival parade.

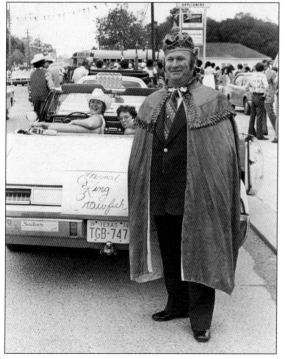

Even cowboys get the blues. Here, Susan Irwin (left) and Ann Newland celebrate the pioneering spirit of the early settlers in 1974.

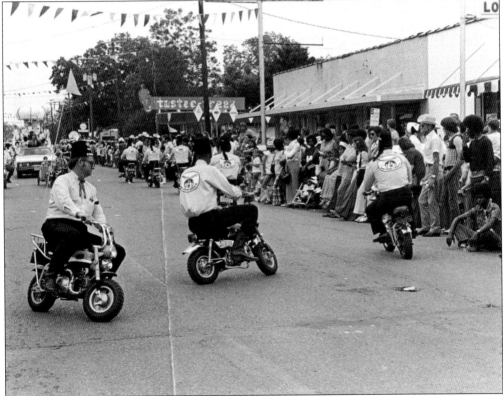

The Ancient Arabic Order of the Nobles of the Mystic Shrine, commonly known as the Shriners, participate in local parades on miniature vehicles, like these motor bikes. They were also part of the parade that celebrated the 1977 Crawfish Festival.

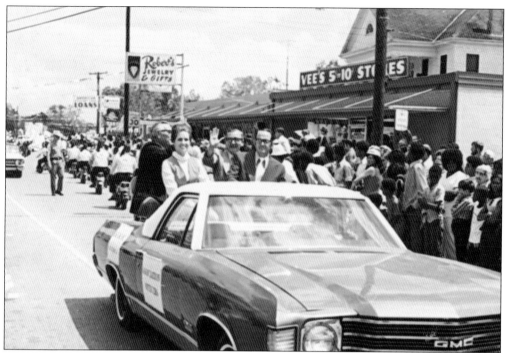

In this image, Pat and Roland Green participate in the 1977 parade.

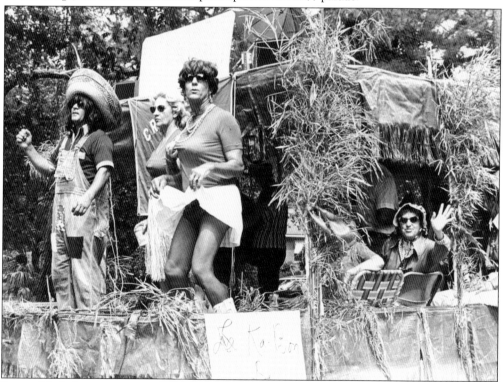

Fun and frolicking were part of the festivities in 1977. These men are dressed in drag on the La Ka-Bon float as it moves down Main Street.

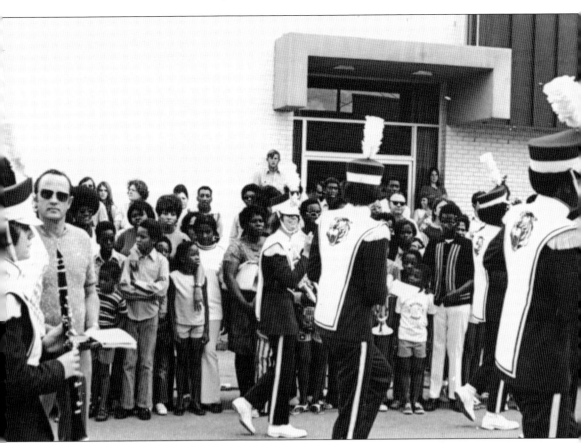

Festival participants enjoy the parade in 1977.

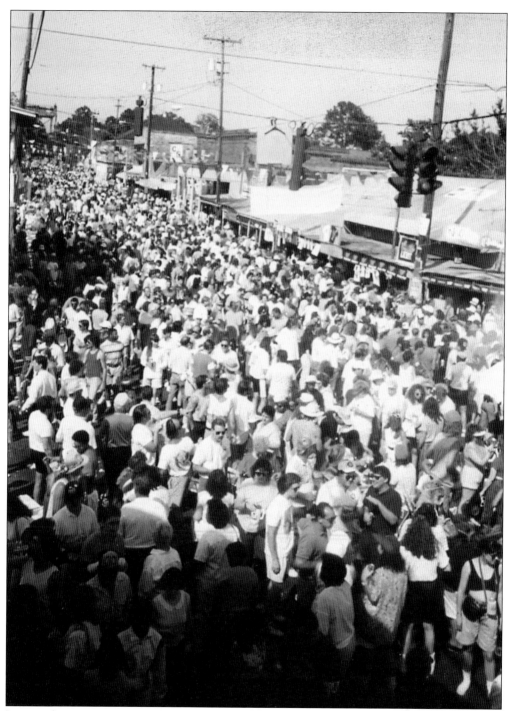

In its earlier years, Breaux Bridge would play host to tens of thousands of people on the streets of downtown. Many say the crowds neared 100,000 and traffic would be backed up for hours in every direction leading into Breaux Bridge. The street celebration spilled over onto nearby lawns, business parking lots, and all places in-between. Due to the huge crowds, the city purchased land and moved the festival to Parc Hardy in 1993.

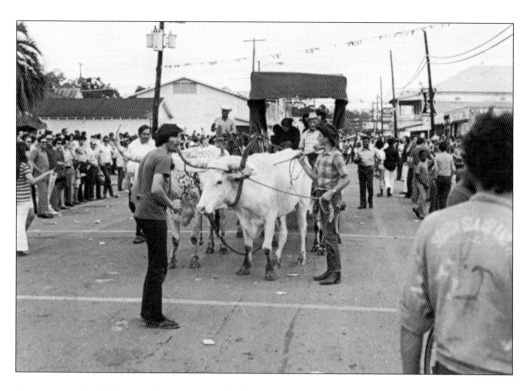

Entrants in the 1977 festival parade included longhorn steers pulling a wagon (above) and a wagon pulled by Shetland ponies (below) to honor the cattle-herding ancestors.

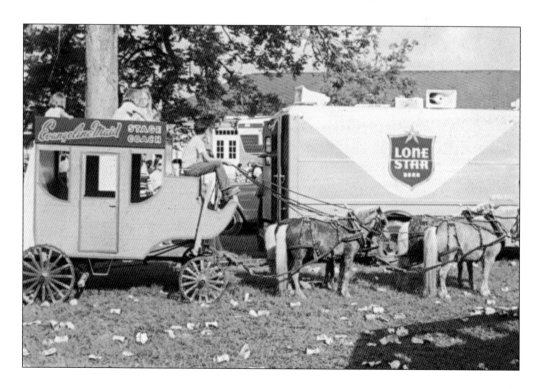

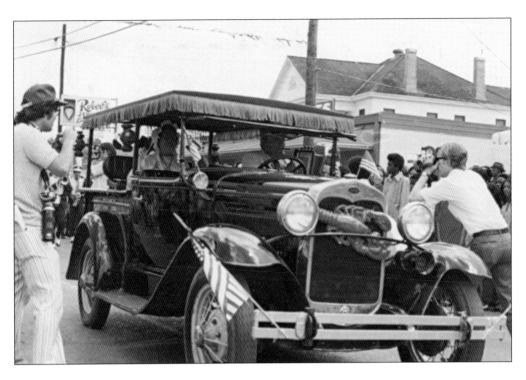

Vintage cars (above) and Shriners (below) were part of the 1977 parade that rode down Main Street. One resident remembers the vintage car enthusiasts in town. They collected and restored the cars and often participated in parades and other events.

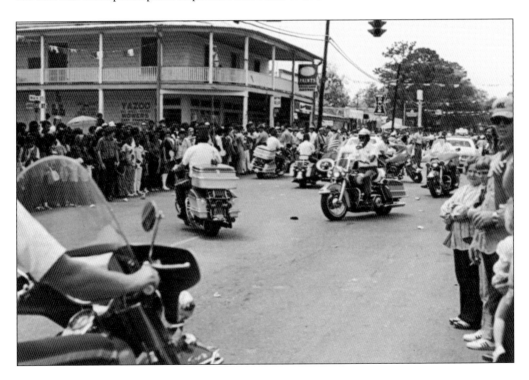

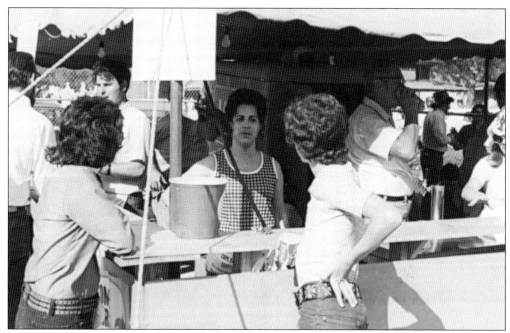

Members of the community greet festival attendees (above) at the welcome booth. Today, the Breaux Bridge Crawfish Festival Association and the Breaux Bridge Department of Tourism greet attendees to the festival at the welcome booth.

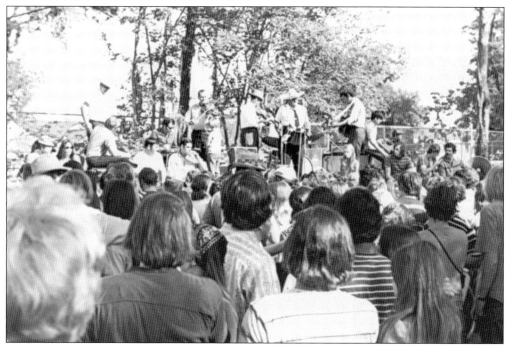

The Crawfish Festival has developed a reputation as one of the best gatherings for Cajun musicians. All weekend, attendees can hear the sounds of authentic Cajun, Zydeco, and Swamp Pop music performed by Louisiana musicians. Each year, more than 30 bands and entertainers perform at the festival. There is also a Cajun dance contest.

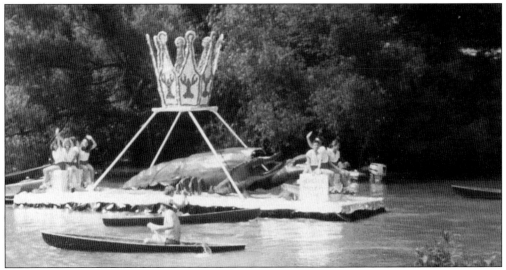

It's all about the crawfish. Before the festival moved to Parc Hardy in 1993, floats traveled up the Bayou Teche. Shown here is a sculpture of the King Crawfish. The original crawfish sculpture was made in 1959 by Peter Holden LeBlanc out of chicken wire and papier-mâché.

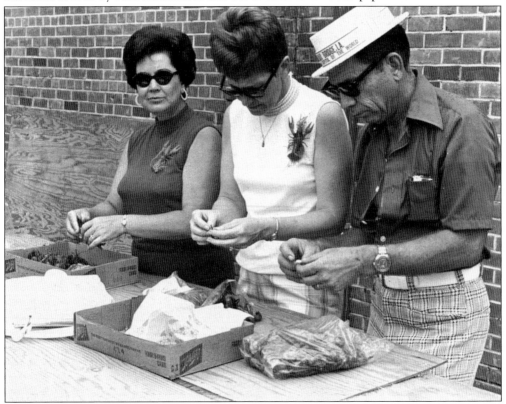

How do you eat a crawfish? You twist it, suck the head for the juice, squeeze it to break the shell a bit, peel away some of the segments, and pinch the tail to pull the meat out. The festival sponsors a crawfish-eating contest. The record is held by Nick Stipelcovich of Metairie, Louisiana, who inhaled almost 56 pounds in one sitting.

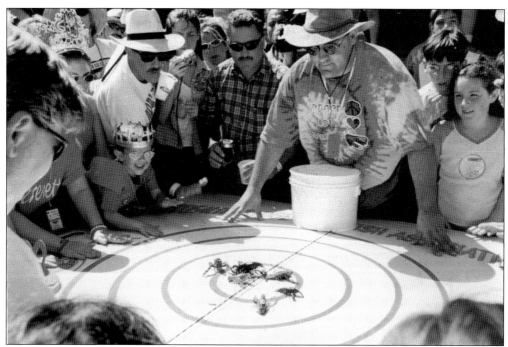

Crawfish racing at the festival was originated by Woodrow Marshall. It has continued to be a popular feature of the festival. This photograph features Mike Clay (center) and Byron Blanchard (in tie-dye shirt) in 1977 cheering their crawfish on during the race. (Courtesy Crawfish Festival Association.)

Ray Broussard and family are seen here on their way to the crawfish races in 1977, with their entry in hand. Even if your crawfish does not win the race, you can always throw him in a pot of gumbo.

At a crawfish boil, everything is cooked in one big pot with the crawfish and seasoning. The contents are then dumped on a table for everyone to stand around and eat. Lemons, onions, rock salt, red pepper, and mustard are added to the pot along with crab boil mix. Part of the ritual is to deeply breath the aroma of the cooking crawfish. The cooks at the crawfish festival, such as those pictured here, cook thousands of pounds of the crustacean during the festival each year.

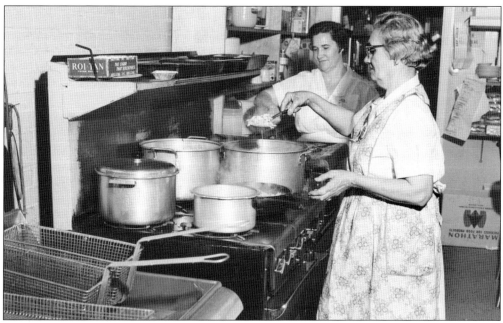

The photograph above is of Marie Blanchard (foreground) cooking crawfish for the 1959 centennial. Blanchard moved to Breaux Bridge in the 1950s and opened Mim's Cafe at 135 North Main Street. She was the inventor of the "crawfish dog," a hot dog stuffed with ground crawfish meat. She was the winner of three blue ribbons for her cooking and was featured in *Better Homes & Gardens*, *Life* magazine, and *Southern Living*. People in Breaux Bridge remember the restaurant for its home-cooked meals. (Above, courtesy St. Martin Library; below, courtesy City of Breaux Bridge.)

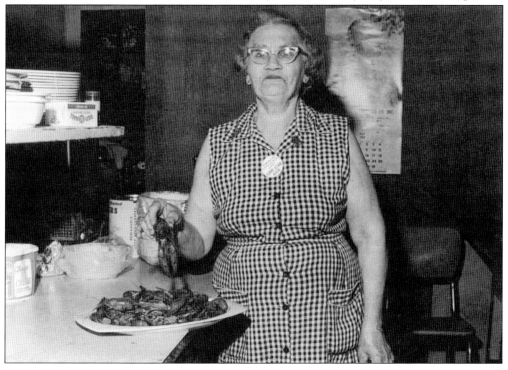

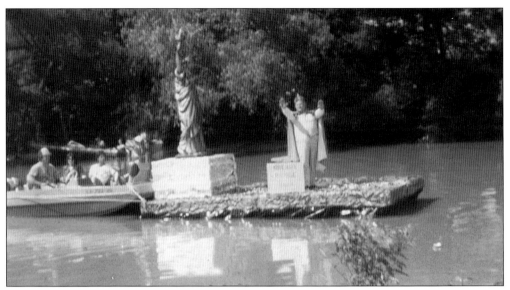

Spokesperson Leon Breaux, also known as the Eternal King Crawfish, makes an appearance at the 1980 festival.

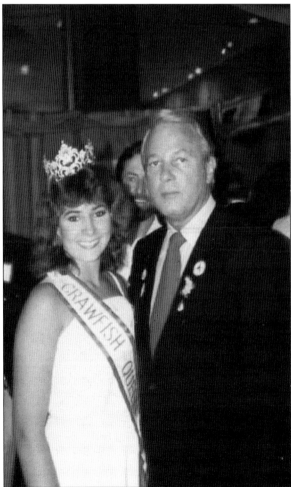

Queen Lydia Frances Green carries on the tradition as Crawfish queen in 1984. Her mother, Emmaline Hebert Thibodeaux, was Crawfish Queen in 1960 and 1961. Lydia poses here with Edwin Washington Edwards, governor of Louisiana (1972–1980, 1984–1988, and 1992–1996) during the festivities. (Courtesy Emmaline Thibodeaux.)

Five

WHO WE ARE

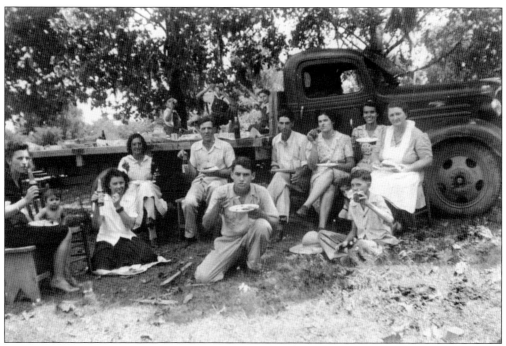

In visiting Breaux Bridge, one will still find names such as Broussard, Thibodeaux, Guidry, Dupius, and, of course, Breaux —descendants of the first 193 Acadians who arrived in Breaux Bridge in 1765. In this photograph, Cajuns are doing what Cajuns do best—eat! This barbeque was held at the home of Cleveland Dupuis. Among those attending were Noe and Jeanne Robert (far right with white apron), Clovis and Flo Guidry Dupius, and Norris Robert (center front). (Courtesy June Robert Gardiner.)

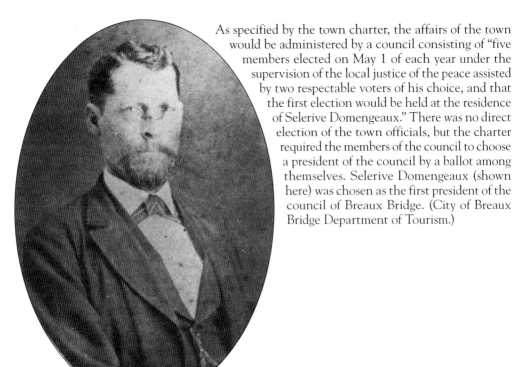

As specified by the town charter, the affairs of the town would be administered by a council consisting of "five members elected on May 1 of each year under the supervision of the local justice of the peace assisted by two respectable voters of his choice, and that the first election would be held at the residence of Selerive Domengeaux." There was no direct election of the town officials, but the charter required the members of the council to choose a president of the council by a ballot among themselves. Selerive Domengeaux (shown here) was chosen as the first president of the council of Breaux Bridge. (City of Breaux Bridge Department of Tourism.)

The Thibodeauxs were among the earliest Acadians to find refuge in Louisiana. Three Thibodeaux families, one led by a widow, five Thibodeaux wives, and several individuals—19 members of the family in all, including several newborns—were among the 193 Acadians who traveled through New Orleans in February 1765 with the large party from Halifax via Cap-Français, Saint-Domingue to Breaux Bridge. Adolph Thibodeaux (shown here in a rare tintype) was born in Breaux Bridge in 1867 and served as one of the state representatives from the area in 1904. (Courtesy Kenneth P. Delcambre.)

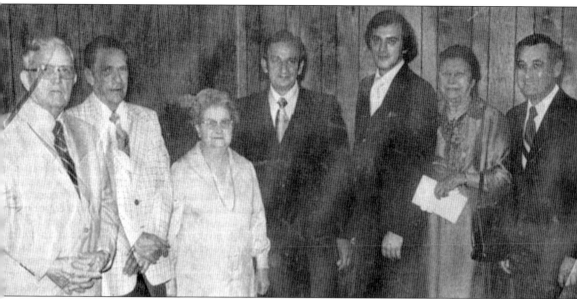

Past mayors of Breaux Bridge were honored during the dedication of the new courtroom and council meeting chambers in March 1977. Shown here are, from left to right, Robert "Bob" Angelle, former state representative and speaker of the house and mayor from 1923 to 1925; Louis Kern (1957–1969 and 1987–1999); Louise LeBlanc, the only woman mayor, who was appointed to complete her husband's term in 1934; Mayor Fred Mills (1969-1977); Terry Theriot, first judge of the Ward 4 City Court; AnnaBelle Krewitz; and Raymond Pellerind. Selerive Domengeaux was the first council president. The names of those who served as president after Domengeaux are not known, until 1877. Beginning in that year, those who served were Oliver Broussard, Joseph Melancon, Valerien Dupuis, Adolphe Dupuis, Charles Delhommer, Leon Dupuis, Dr. H.M. Neblett, Onesiphore Badon, George D. Domengeaux, R.L. Morrow, Claude Rees, David Trahan, Dr. C.W. Boring, F.F. Guilbeau, George Champagne, Leonce Pellerin, Robert Angelle, Henry Mills, Holden LeBlanc, Mrs. Holden LeBlanc, Rex Begnaud, George Hebert, Louis Kern, Fred Mills Sr., Vance Theriot, Louis Kern, Fred Mills, and the present mayor, Jack Dale Delhomme. (Courtesy the *Teche News* files.)

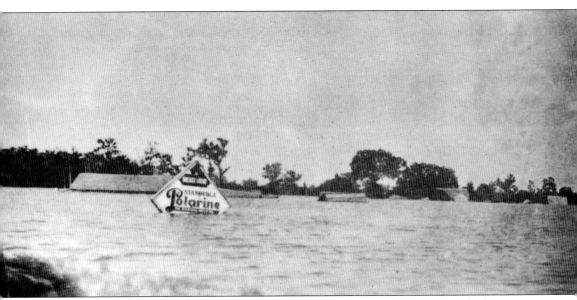

Historians disagree on what caused the 1927 flood. Some argue that a break in the levee system was the only cause of the flood. However, others believe that the torrential rains that begin in December 1926 and continued through the spring of 1927 caused the levees to break. The flood is reported to have caused over $400 million in damages and killed over 250 people. The Teche began to flood in May 1927, when the waters from the Bayou des Glaises and Atchafalaya River joined the floodwater in northern St. Martin Parish, causing the levee to break in the St. Martin Parish Protection Levee. On May 22, the west bank of the Teche overflowed, covering Main Street. Before it was over, the entire city of Breaux Bridge was covered in water. There are few photographs of the city during the flood, as the residents were forced to evacuate to higher ground with very little of their possessions. Stopping to take photographs of the encroaching waters was the last thing on their minds. Many traveled on foot to Lafayette to refugee camps; some joined relatives in neighboring cities and states. Gerald Champagne remembers evacuating with his family. "We were provided a farm house in Lafayette," he says. "We left with very little belongings and a few chickens on a flatbed. The chickens gave us eggs and sometimes meat. Everything was cooked on an open fire in the back yard. We returned while the water was down but still there," he adds. "The crops were ruined. Water entered all the homes. My mother would walk through the water to an aunt's who was on higher ground, with me on her back, to get some drinking water."

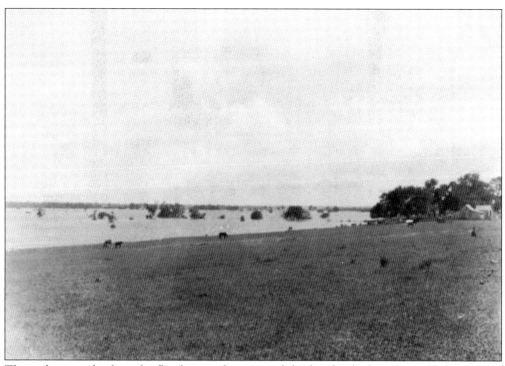

These photographs show the floodwaters that covered the farmlands along Bayou Teche in 1927. Parts of the town were under 25 feet of water.

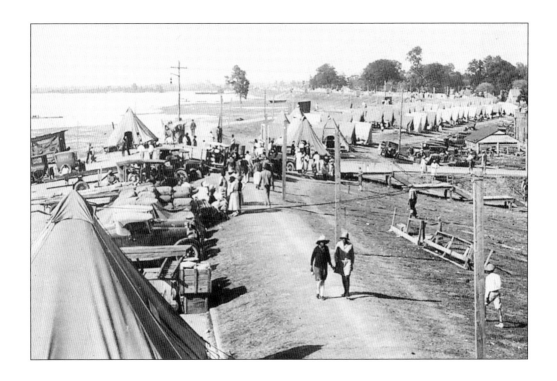

Refugee camps were established in Lafayette and surrounding cities to accommodate thousands of families whose homes had been flooded. The Red Cross issued sheets, blankets, and medicine. Residents were given tents in which to live. Often, two families shared a tent.

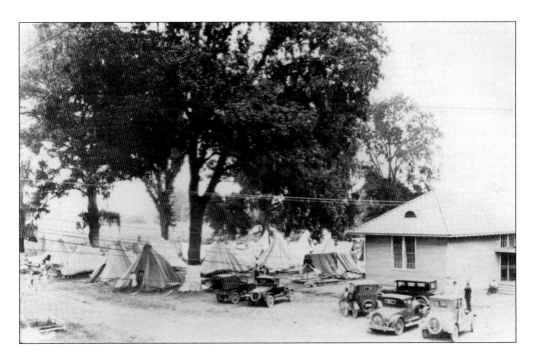

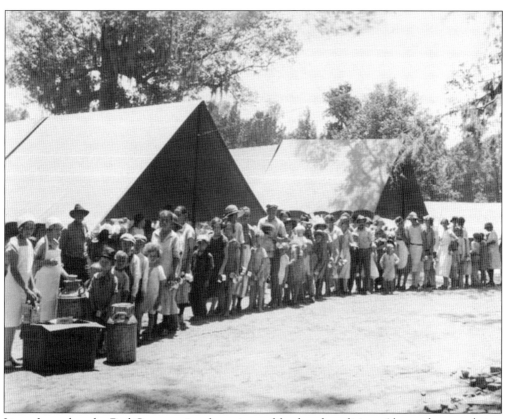

Lines formed at the Red Cross station for rations of food and medicine. Above, shots are being administered at the Red Cross station in Lafayette. The below photograph shows one of the refugee camps. Tents were erected as living quarters. (Courtesy Kenneth Delcambre.)

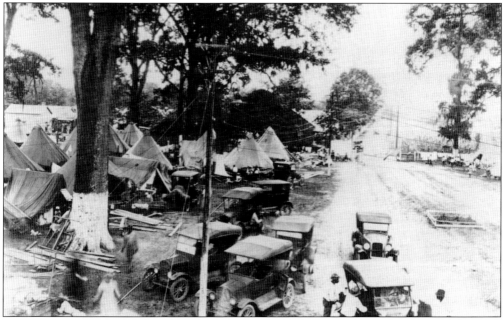

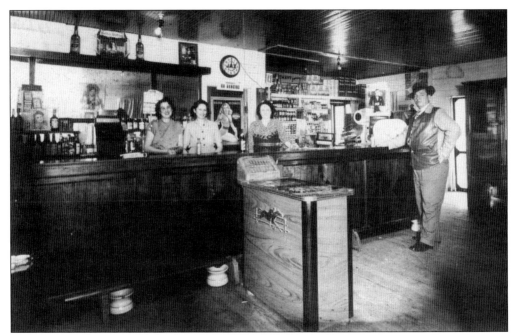

By 1948, Breaux Bridge had recovered from the flood, and business began to flourish again. This photograph shows one of the many businesses in Breaux Bridge in 1948. From left to right, Margaret Melancon, Inez Melancon-Patin, Alice Melancon, and an unidentified customer. (Courtesy Kenneth Delcambre.)

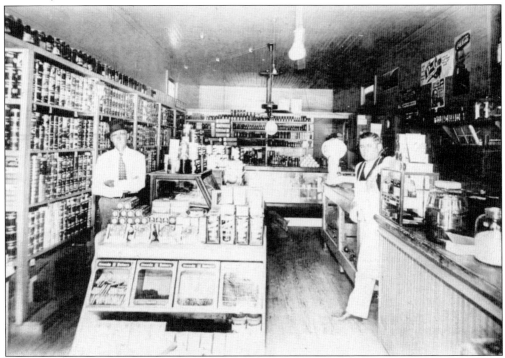

Joe Cormier's Grocery Store, seen here in 1949, was one of the country stores in the area. Joe Cormier is on the right in this photograph. (Courtesy Kenneth Delcambre.)

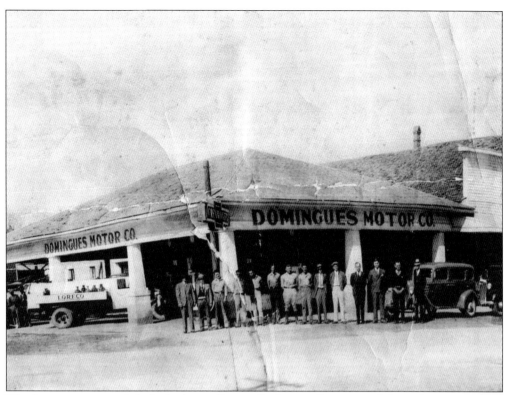

The first major automobile dealership in Breaux Bridge was Domingues Motor Company, which opened in 1923. The owners were J.A. Domingues, Adlai J. Domingues, and L.S. Domingues. (Courtesy Coatney and Johnny Raymond.)

Buck and Johnny's restaurant is now located in the spot that Domingues Motor Company once occupied. (Courtesy Coatney and Johnny Raymond.)

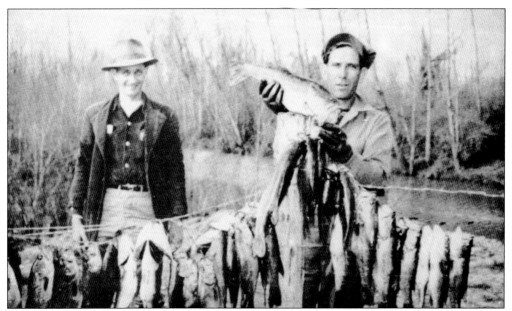

Sidney Tauzin (left) and "Mulate" Guidry are shown fishing in the Atchafalaya Basin in 1952. Guidry was the owner of Mulate's, one of the most popular Cajun restaurants and dance halls in Breaux Bridge. Guidry first ran the Rendezvous Club, which was opened in 1937 by his father, Henry Guidry. The Rendezvous Club was a saloon-type dance hall in an area, known as Henderson, that had roads and automobiles and limited railroad service. Mulate took over the club about 1953, moving it from Henderson to nearby Breaux Bridge and renaming it Mulate's. Located at 325 West Mills Avenue (Highway 94), Mulate's was visited by many well-known celebrities, such as Robert Duvall, Paul Simon, Meg Ryan, Oliver Stone, Dennis Quaid, and Ron Howard. In 1980, Kerry Boutte purchased Mulate's and expanded it. In 1989, Goldie Comeaux purchased the establishment and operated it until her death in 2008. The family kept the restaurant running until Hurricane Gustav tore the roof off the building in 2008. They rebuilt the restaurant and then sold it to longtime manager Jimmy LaGrange, who renamed it Pont Breaux's Cajun Restaurant. (Courtesy Kenneth P. Delcambre.)

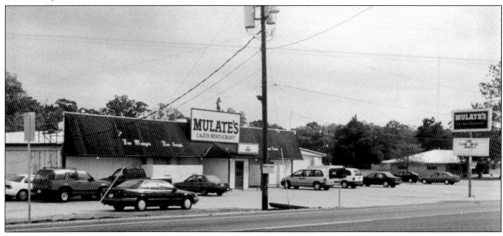

Mulate's restaurant is pictured here in 1968. Many people have fond memories of Mulate's, which was part of Breaux Bridge from 1953 until 2011. In addition to authentic Cajun food, the club featured Cajun musicians performing nightly.

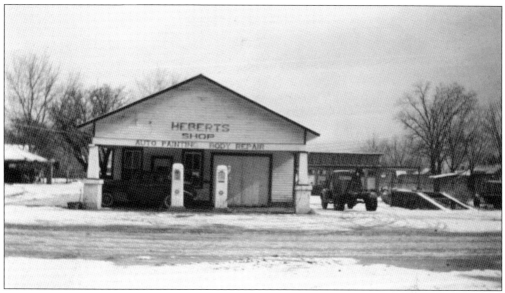

Chester Hebert Sr. owned Hebert's Shop, at the corner of Berard and Martin Streets. He and his wife, Blanche Edwina Crowder Hebert, lived next door at 225 Berard Street. (Courtesy Lucien Hebert family via Kim Dever Thibodeaux.)

Chester Hebert opened Hebert's Auto Sales around 1948. A new facility was built in 1969, and the name was changed to Hebert GMC.

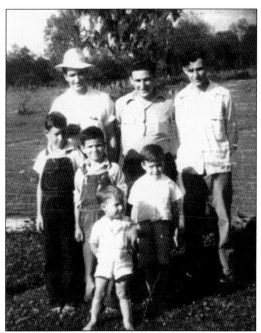

The Acadians who settled the area were surrounded by family. Many of the families had several children who helped work the farms. In the image at left are, from left to right, (first row) Joseph Hebert III, Jack Harris Hebert, Rufus Hebert, and Isaac Hebert; (second row) John D. Hebert, Jim Hebert, and George Hebert. The family also had four daughters, not pictured: Lillian Hebert, Belzire Hebert, Mary Rose Hebert, and Mary Jane Hebert. The family had a total of 11 children, who helped with daily chores and fieldwork. The Hebert family raised chickens and cattle to supplement their food source. They lived in a home on the banks of the Bayou Tech. The below photograph shows Joseph Hebert Jr. with Isaac Hebert, the youngest of his children. Joseph was the father of 11 children, including the Hebert boys pictured above. (Courtesy Emmaline Hebert Thibodeaux.)

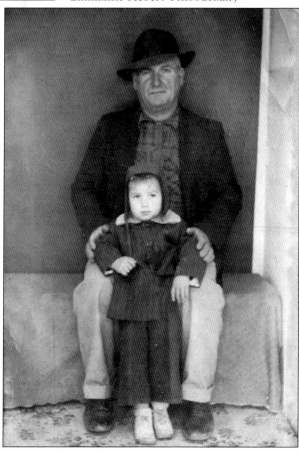

Emmaline Hebert Thibodeaux, the first
Crawfish Queen and daughter of John
D. Hebert, is seen here in a photograph
taken when she was about three years old.
(Courtesy Emmaline Hebert Thibodeaux.)

Gerald and Anna Lee Champagne are seen
here as children on the farm in Breaux
Bridge in this 1932 tintype. (Courtesy
Gerald Champagne.)

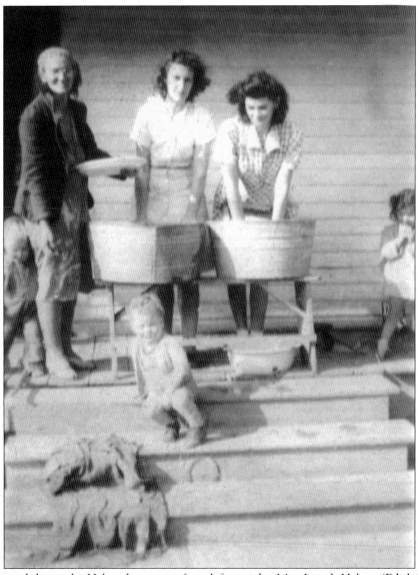

Seen on washday at the Hebert house are, from left to right, Mrs. Joseph Hebert (Edith Webre), daughter Mary Rose Hebert, Bernice Hebert, Rusty Clark (on the step), and Nelma Hebert (far right). Before the invention of the electric washing machine, Monday was the designated day for doing the weekly wash on most farms. This routine started early in the morning. All farms had a large cast iron pot standing on three short legs. Wood was piled under and around the pot to heat the water. Water had to be carried in buckets from the cistern, which collected rainwater that drained from the roof. This was also the source of drinking water. Detergents were not available in those days; most housewives used a large yellow bar of soap called Octagon soap. This was an improvement over the homemade lye soap that was once used. The soap was purchased by the case, and the wrappers were immediately removed in order to cut out the coupons. The children were given scissors and assigned the job of unwrapping each bar and cutting the coupon. There was no fast food in those days, and the wash person had little time for kitchen duties. Gerald Champagne remembers that each Monday, "a dried shrimp stew with rice was the standard fare. Also, Irish potatoes were boiled until they resembled a soup." (Courtesy June Robert Gardiner.)

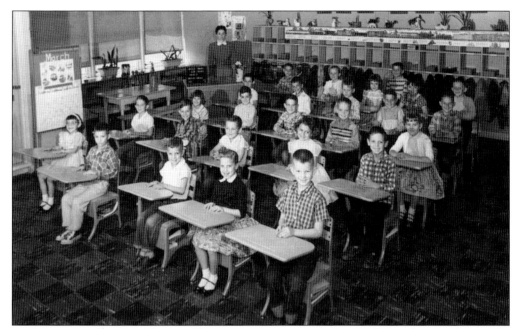

In this vintage classroom photograph, Genevieve "Genny" Hebert is the teacher standing in the back. Chester "Butch" Hebert Jr. (first row on the right) is one of her students. (Courtesy Lucien Hebert family via Kim Dever Thibodeaux.)

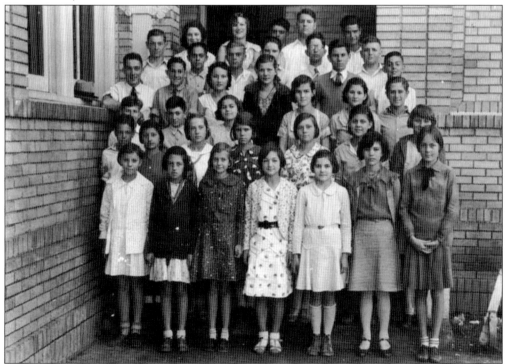

In this class photograph, Genevieve "Genny" Hebert is at center in the first row. The photograph was taken in Breaux Bridge, Louisiana, around 1920. (Courtesy Lucien Hebert family via Kim Dever Thibodeaux.)

Julie Ann Champagne is seen here as a baby. She was born in Breaux Bridge in 1890 to Denis and Modeste Patin Champagne. She married Gaston Thibodeaux and had four children. (Courtesy Gerald Champagne.)

During the early part of the 20th century, everyone pitched in to pick cotton, including the children, who would be equally tired in the evening after working all day.

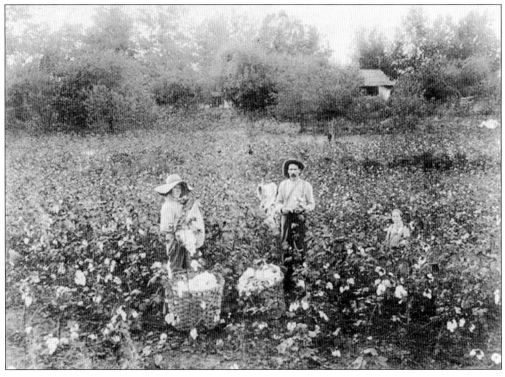

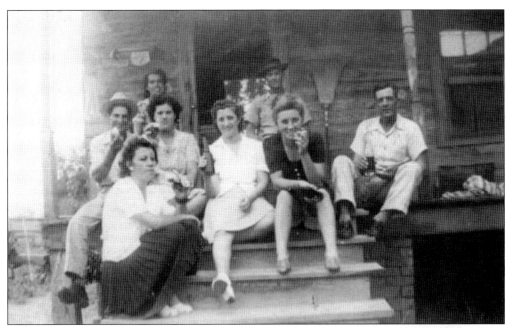

At the end of a hard day working in the fields, families often gathered on the front porch to cool off. This photograph includes Bertha Bower Robert (Luke Robert's wife) and Edith Trosclair Dupuis (Cleveland "Jacques" Dupuis's wife) on the front porch of their home. (Courtesy June Robert Gardiner.)

Volma "Bebe" Landry (left) poses on the front porch with his wife, Osiana "Sion" Landry, and a nephew in early 1950. (Courtesy Shirley Ann Landry Robert.)

James Hebert, one of the 11 children of Joseph Hebert Jr. and Edith Webre, poses with his wife, Bernice, and daughter, Nelma Hebert. James and his brother John were soldiers in World War II. (Courtesy Emmaline Hebert Thibodeaux.)

Shown here in 1942 are, from left to right, Noe Robert, Norris Noe Robert, Jeanne Bertrand Robert, and Luke Robert. Luke was a soldier in World War II, and Norris served in the Korean War.

Mildred Rose Breaux Hebert poses with
two of her children, Emmaline Hebert (on
her lap) and Clifford, at Easter time on
the Hebert family farm. Emmaline later
became the first Crawfish Festival Queen.
Mildred, or Aunt Toot, as she was called,
began her romance with John D. Hebert
when she would cross the Bayou Teche in
a boat to visit the Hebert family, because
they had so many children, especially
girls, to play with. She was part of an
extended family that lived across the bayou.
(Courtesy Emmaline Hebert Thibodeaux.)

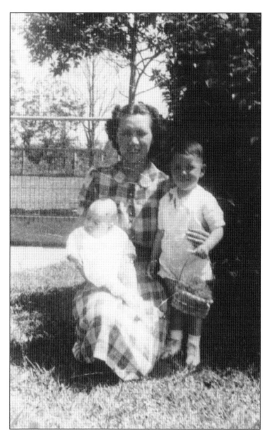

Clifford Hebert is pictured here as an adult.
He was the oldest of seven children born
to Mildred and John Hebert. He was born
in 1941 on his father's birthday, July 12.
(Courtesy Emmaline Hebert Thibodeaux.)

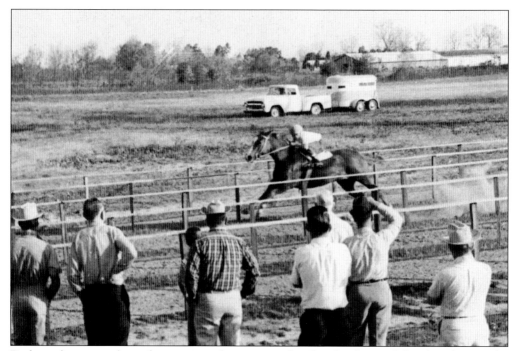

Bush-track racing refers to horse racing that is unregulated and unlicensed. It takes place in the fields and prairies in Southwest Louisiana. Volma "Bebe" Landry was a jockey at one time, and he raised horses in Breaux Bridge. His daughter Shirley Landry Robert says that everybody used to race horses. "Wherever there was a short lane or a dirt track, they would race their horses," she says.

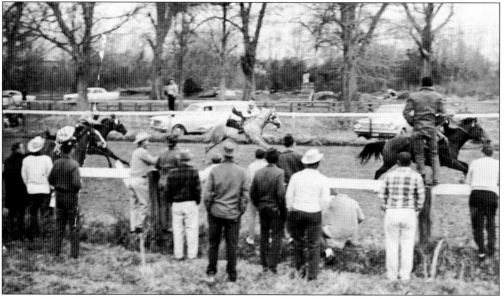

At one time, bush tracks could be found everywhere along the grasslands that hug the swamps and bayous of the Atchafalya basin. In the 1930s, 1940s, and 1950s, hundreds of bush tracks were part of the Cajun culture. Today, there are only a few. Racetrack owners closed the tracks due to the increase in lawsuits by injured jockeys and because of the rising cost of insurance.

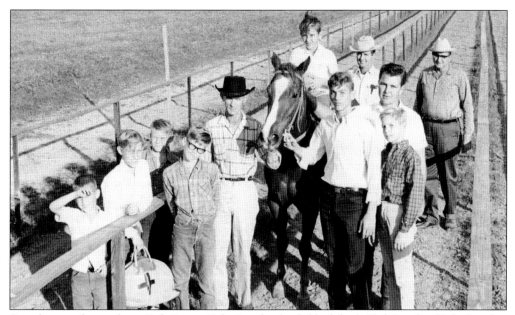

Seen here at the track are Bob, Larry, Bebe Landry (with black hat), Kirk Landry, Kirby Landry, Charles Mason, Carlton "Kit" Castille, and Francis Castille. They are preparing for a race in the dirt of a brush track. Horses from Breaux Bridge often rode in licensed races at the Evangeline Race Track, formerly in the Lafayette/Carenco area, and the Fair Grounds Race Course in New Orleans. (Courtesy Shirley Ann Landry Robert.)

Getting ready to race! Bebe Landry (on left) was well known in the area for his horses that raced on the bush tracks. He is shown here with Ray Broussard (far right) and jockey Harry Lee Patin (on horse). Several famous jockeys began their careers on the Cajun bush tracks, including Calvin Borel, who rode the winning horses for three Kentucky Derby races. (Courtesy Shirley Ann Landry Robert.)

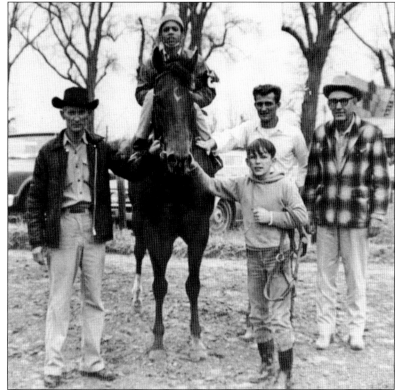

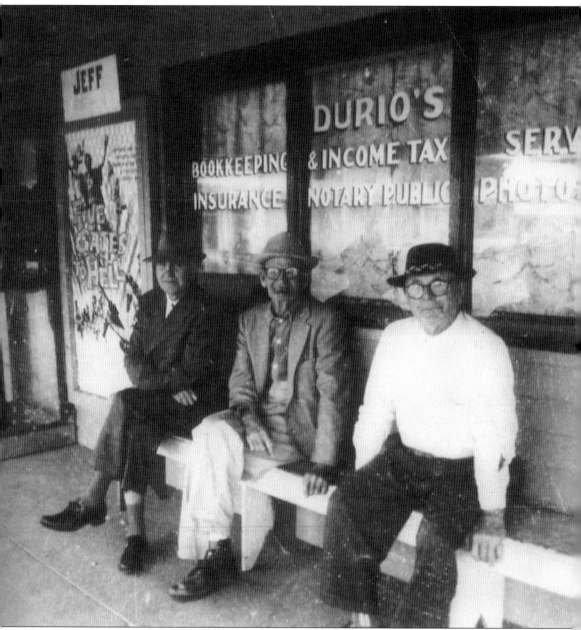

By 1960, Breaux Bridge had made it through the 1927 flood, the Great Depression, and two world wars. In this photograph, Nazaire Thibodeaux (left), Albert Benaud (center), and William Bourdier gather at the corner of Main and Bridge Streets to reminisce about things past. (Courtesy Kenneth P. Delcambre.)

The above photograph shows Leo Pierre Champagne in 1908. He served in the Civil War in Company E, Consolidated 18th Regiment and Yellow Jackets Battalion. He is seen in his uniform in the below photograph. Champagne died on December 24, 1909, and is buried in the St. Bernard Catholic Cemetery in Breaux Bridge. (Courtesy Gerald Champagne.)

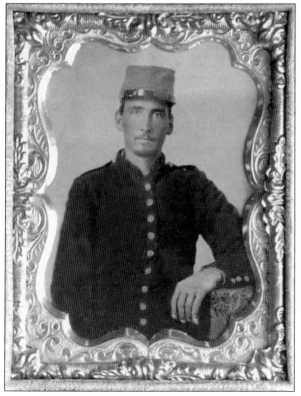

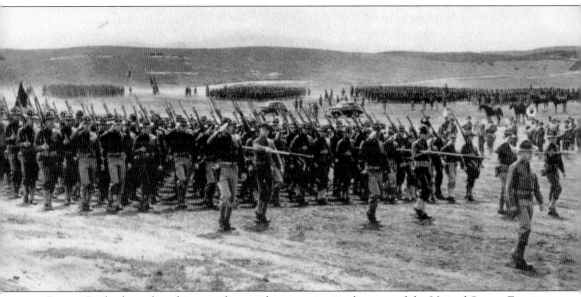

Breaux Bridge has a long history of its residents serving in the wars of the United States. Firmin Breaux and many of the early settlers along Bayou Teche served in the American Revolutionary War, capturing the British forts in the lower Mississippi Valley in 1779. Residents also served in the Civil War and the Spanish-American War. The first Civil War encampment of Union Troops was recorded on April 21, 1863. During World War II, the descendants of the French-speaking Acadian settlers served as interpreters for their unit's American and French officers. The soldiers grew up speaking French in Southwestern Louisiana, but they had never regarded their ability to speak French as an asset. In fact, they had been punished for speaking French at school. However, in 1941, when they were drafted to serve in the military, their ability to speak French soon became an asset, and they were pressed into service as translators. The Cajun soldiers found that they were well received in France during the war. Over 90 soldiers from Breaux Bridge and the Bayou Teche area served in World War II. As members of the 156th Infantry Battalion, (below), they were inducted into federal service on November 25, 1940, and went to Camp Blanding in Florida for basic training. The city erected a memorial in City Park in their honor. There is also a memorial honoring those who served in the Korean War and the Vietnam War.

Clayus LeBlanc was born in St. Martin Parish on April 26, 1890, and died on October 27, 1952. He is buried at Sts. Peter and Paul Catholic Cemetery in Scott, Louisiana. His parents were Jean Ozeme LeBlanc and Elmire Babin. His siblings were Homer, Holden (future mayor of Breaux Bridge), and Edith. Clayus LeBlanc was living in Shelby, Mississippi, on June 5, 1911, when he registered for the draft. At that time, he was employed as an assistant cashier at the Shelby Bank. He enlisted on October 1, 1917, and was discharged on July 11, 1919. He achieved the rank of sergeant with the 211th Company of the Army. He was married to Lucille, and they had a daughter, Mary Frances. She married Louis Doucet, and they are the parents of Michael and David Doucet of the Cajun band Beausoleil.

John Harry LeBlanc poses on a motorcycle during World War II in Europe.

113

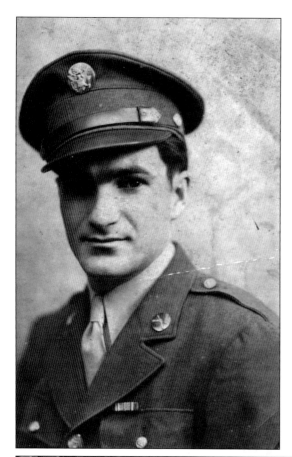

S.Sgt. John D. Hebert served in World War II with Company F of the 156th Infantry Battalion of the Breaux Bridge National Guard unit. During the war, he served as a barber, tailor, and interpreter for high-ranking officers. After the war, he opened a gas station and community bar where people came to buy tires, gas, and food, including hotdogs and hamburgers, and snowballs. (Courtesy Emmaline Hebert Thibodeaux.)

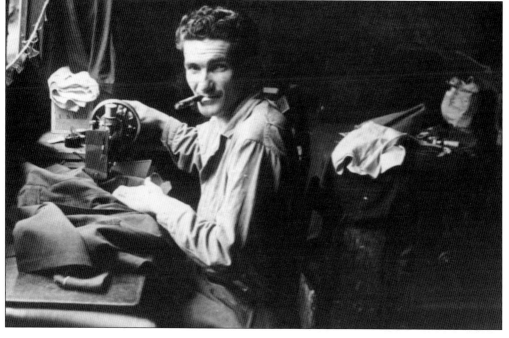

During the war, John Hebert asked fellow soldiers to take photographs of him that he could send home to his wife, Mildred Rose. Serving as a tailor, barber, and interpreter, he traveled back and forth between England and France. Here, Hebert (in the background) is shaving while the train is stopped.

John Hebert's brother James also served in the Army during World War II. James, a sergeant, received several awards and citations for his valor. Both John and James returned to Breaux Bridge after the war. James married Bernice Boudreaux.

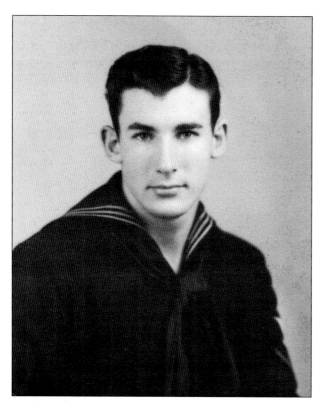

Gerald Champagne is seen here in 1941 at age 19. He was a specialist X with the US Coast Guard Intelligence Department, 6th Naval District (Wilmington, North Carolina; Charleston, South Carolina; Savannah, Georgia; and Jacksonville, Florida). (Courtesy Gerald Champagne.)

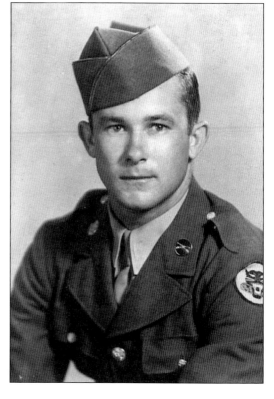

Wallace LeBlanc served in the 3rd Division tank battalion under Gen. George Patton. He drove General Patton during the time he visited their combat area. He was also asked to be one of the honorary color guards/pall bearers at Patton's funeral. Because LeBlanc spoke French, he was in charge of confirming visitors to the base. He told the story of how he denied French president Charles de Gaulle access because he did not have the required papers or identification.

Luke Robert served from 1940 to 1945 with the 156th Infantry Battalion during World War II. The 156th was inducted into federal service on November 25, 1940.

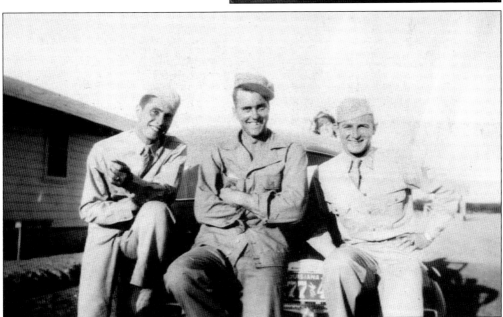

Company F members Luke Robert (right), Howard Dupius (left), and Maurize Perez (center) are seen here during basic training at Camp Blanding, Florida, in 1941. Robert and Dupius were from Breaux Bridge. (Courtesy June Robert Gardiner.)

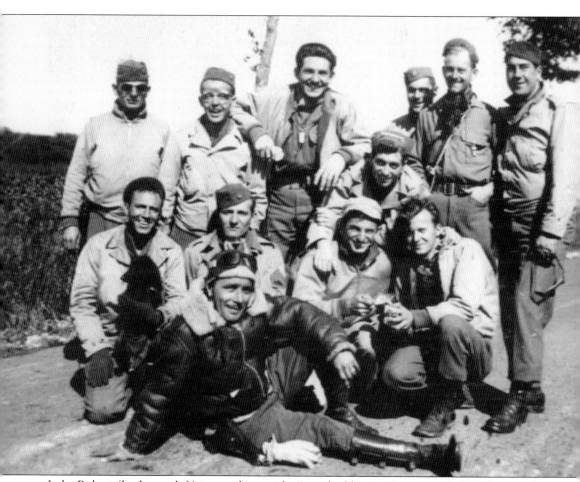

Luke Robert (back row, left) is seen here with Army buddies in Germany in 1945. During the war, Corporal Robert served in the Army as a military policeman in Italy, France, and Germany. (Courtesy June Robert Gardiner.)

Johnny Raymond served in the military for 20 years (1945–1946 and 1950–1969). He was an Airborne Ranger and a member of the Special Forces. During World War II, he served in the US Naval Air Corps as an aerial gunner on a torpedo bomber in Seattle, Washington. He fought as a platoon leader and company commander in the 5th Regimental Combat Team in Korea, and in Vietnam with units of the II Field Force. (Courtesy Coatney and John Raymond.)

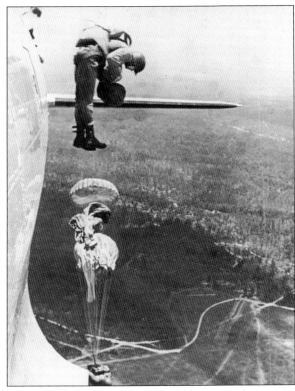

This photograph shows Johnny Raymond skydiving in the military. Raymond was born in Rayne, Louisiana, on December 15, 1927, and moved to Breaux Bridge when he was six years old. (Courtesy John Raymond.)

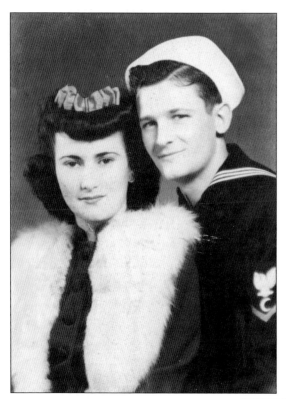

Belzire Hebert (left), daughter of Joseph Hebert, traveled by train in August 1944 to meet her longtime sweetheart, who was stationed in San Diego aboard a US Navy ship. She married Ivan John Gravouilla on August 24, 1944. Ivan was a cook on one of the ships harbored at the naval station in San Diego. Belzire told her daughter about how she got a job at the Kress five-and-dime store, and how the couple visited Balboa Park and enjoyed their free time in San Diego.

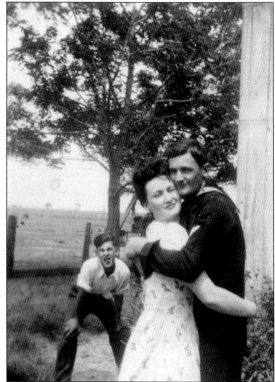

Ivan Gravouilla, on leave from the Navy, visits with his wife, Belzire Hebert, in Breaux Bridge. Gravouilla's brother Nolan is in the background making faces.

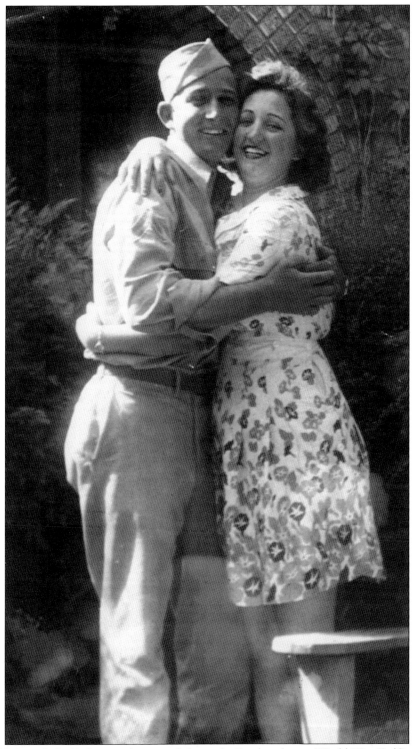

Pictured here is Luke Robert on leave with his wife, Bertha, during World War II. (Courtesy of June Robert Gardiner.)

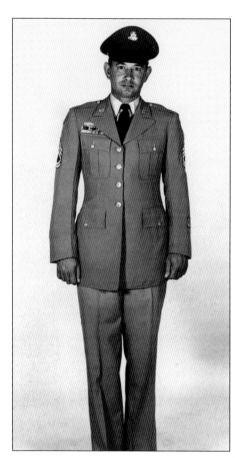

Soldiers from Breaux Bridge also served in the Korean War. Pictured here is S.Sgt. Norris "Noe" Robert. He served in Korea from 1948 to 1950. His Army career spanned from 1947 to 1967. He is now retired and still lives in Breaux Bridge. During his career, Robert received a Combat Infantry Badge, Paratrooper Badge, Bronze Star, three Purple Hearts, Commendation Medal, United Nation Medal, Korean Service Medal, Occupation Medal, and Good Conduct Medal.

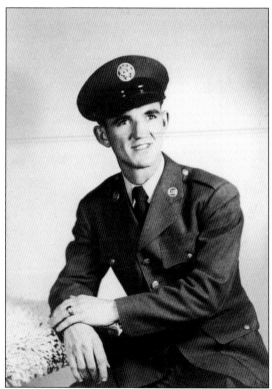

Pictured here is Lucien Henry Hebert Jr., who served in the Korean War.

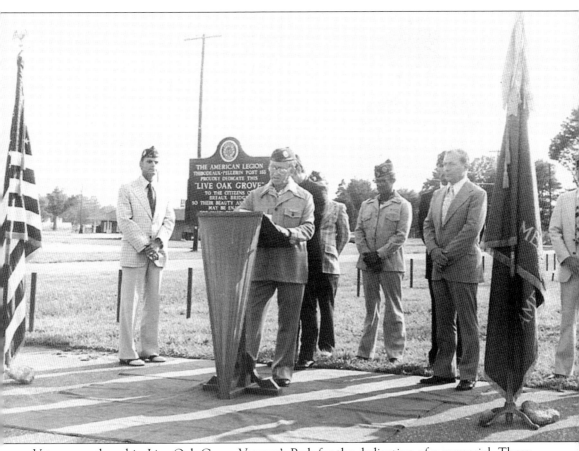

Veterans gathered in Live Oak Grove Veteran's Park for the dedication of a memorial. Those gathered include Rodney Broussard (front), Dewey Coles (far left), Wallace LeBlanc (right), Vance Theriot (second from right), and Chester Sonnier.

Since World War II, surviving members of Breaux Bridge's Company F, 2nd Battalion, 156th Infantry Brigade have gathered to observe the anniversary of the mobilization of the unit for World War II.

Surviving members of Breaux Bridge's Company F, 2nd Battalion, 156th Infantry Brigade gather on a porch for a photograph in 1996.

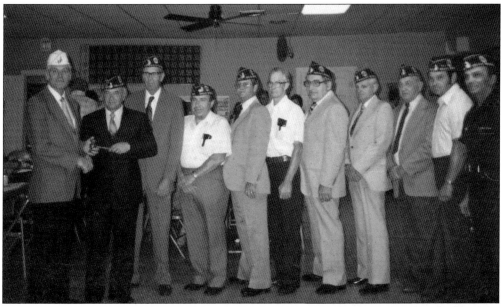

S.Sgt. Norris Robert (second from left) served in the Korean War. He was the commander of the Breaux Bridge Veterans of Foreign Wars in 1984.

Hunter Hayes and Ali Landry are some famous Cajuns from Breaux Bridge. Heartthrob Hunter Hayes got his start in his hometown. Born in Breaux Bridge, he performed at the Crawfish Festival as a child (seen here).

Ali Landry was the first Cajun crowned Miss USA, in 1996. Landry grew up in Breaux Bridge. She attended the University of Louisiana at Lafayette.

BIBLIOGRAPHY

Brasseaux, Carl A. *The Founding of New Acadia: The Beginnings of Acadian Life in Louisiana, 1765–1803*. Baton Rouge: Louisiana State University Press, 1987.

Conrad, Glenn R. *The Cajuns: Essays on their History and Culture*. Lafayette: University of Southwestern Louisiana, 1983.

Faragher, John Mack. *A Great and Noble Scheme: The Tragic Story of the Expulsion of the French Acadians from their American Homeland*. New York: W.W. Norton & Company, 2005.

Rees, Grover. *A Narrative History of Breaux Bridge: Once Called "La Pointe."* St. Martinville, LA: Attakapas Historical Association, 1976.

DISCOVER THOUSANDS OF LOCAL HISTORY BOOKS
FEATURING MILLIONS OF VINTAGE IMAGES

Arcadia Publishing, the leading local history publisher in the United States, is committed to making history accessible and meaningful through publishing books that celebrate and preserve the heritage of America's people and places.

Find more books like this at
www.arcadiapublishing.com

Search for your hometown history, your old stomping grounds, and even your favorite sports team.